CW00403483

FARFETCH CURATES DESIGN

ASSOULINE

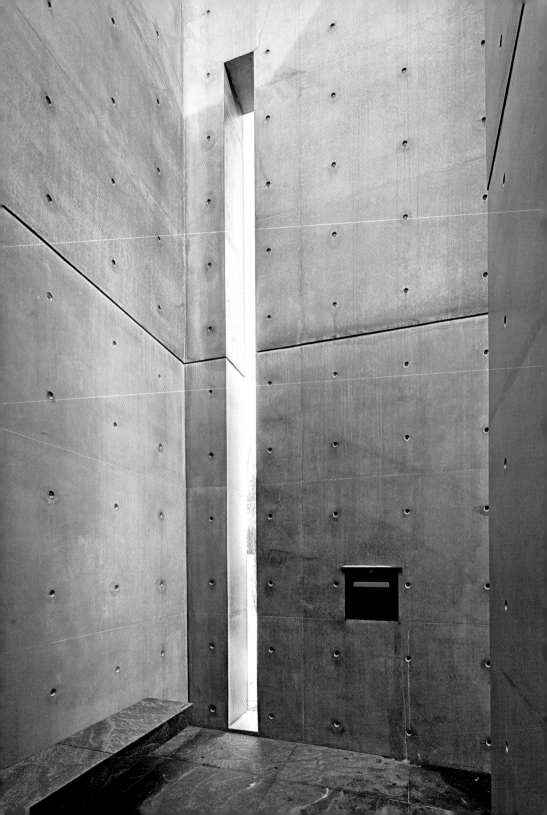

CONTENTS

The entrance to Farfetch boutique owner Linda Dresner's home, designed by Steven Sivak.
See page 52 for the full feature.

DESIGNS ON
JOHANNA
AGERMAN ROSS

Recently, my inbox has turned into a cornucopia of design-related fashion news. It revealed that Loewe's creative director J.W. Anderson has collected design classics, ranging from William Morris to Charles Rennie Mackintosh, for the brand's boutiques; Prada has unveiled an intriguing look by designer Martino Gamper for its worldwide window displays; and Hedi Slimane, of Saint Laurent, used the work of the Union des Artistes Modernes as inspiration for the label's new stores globally.

Collectively, these snippets serve as proof that the fashion boutique is the most public space where the worlds of fashion and design converge.

As the grande dame of interior design Andrée Putman said of her work in fashion: 'I've always worked with the idea of making beautiful things accessible to everyone by promoting new products in an original manner.' Store design is all about making an object desirable and approachable in equal measure.

Interior architecture embodies the identity of a boutique or brand and serves as a platform for the items it retails. But while the garments and accessories come and go seasonally, there is a permanence to the interior, and this is the long-running tension between the two: Fashion is by definition fleeting; design is longer lasting. The relationship, however, is mutually beneficial. Fashion gives design currency, and design gives fashion depth, anchoring it to a wider history.

As this book shows, design in its broader sense – furniture, objects, interiors, and buildings – also forms part of the cultural landscape that influences both fashion's designers and retailers. The raw lines of a parking garage by architects Herzog & De Meuron serve as the perfect backdrop for a uniquely crafted Rodarte dress, while a visit to the beautifully appointed Six Senses hotel in Oman provides off-duty inspiration for shoe designer Nicholas Kirkwood.

The relationship between design and fashion is intriguing to consider, and this book is an enticing start.

OBJECTS OF
AFFECTION

Barcelona-based *Apartamento* magazine is renowned for its everyday approach to interior design. Subverting the journalistic predisposition for staging interior settings, *Apartamento* celebrates real spaces, with the crumbs, clutter, and chaos included. Turning the camera back on the magazine's operator, Farfetch met with cofounder Omar Sosa at his apartment just off Plaça de Catalunya to catch a glimpse of the items he treasures most in his own home:

Table with Objects
'This is a little arrangement of geometric objects found around the world. I like these essentially useless small objects for their materiality and shape. Some have an amazing weight and texture, and some are developing a very nice patina over time.'

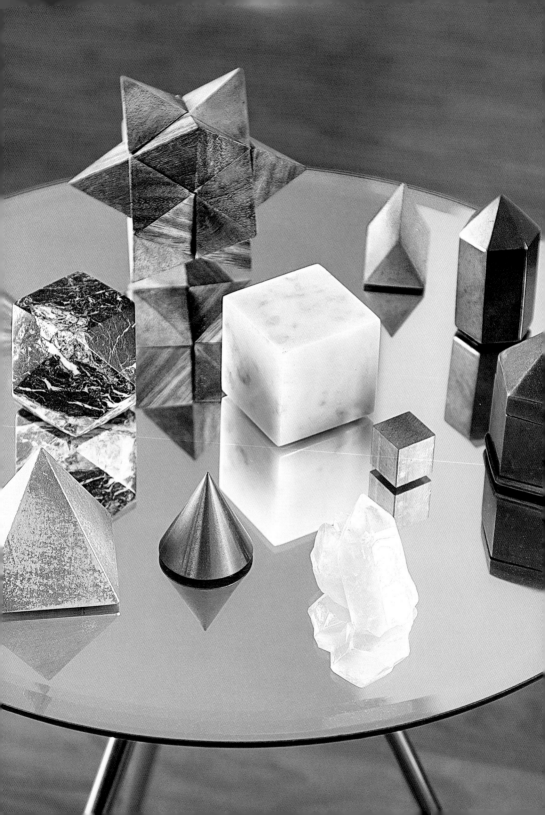

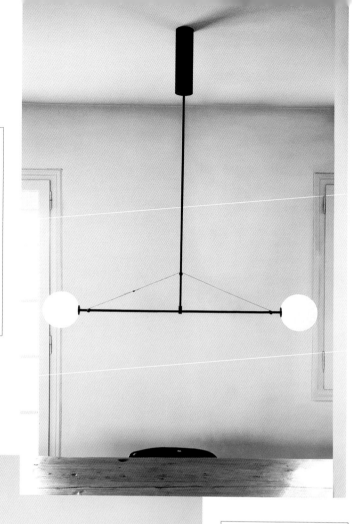

Mobile chandelier by Michael Anastassiades
'Michael gave me this lamp after I designed a catalogue for him. I see it as a sculpture rather than a light fixture. It has a beautiful form and, besides providing great light, makes the whole table space more interesting.'

Painting by Nathalie Du Pasquier
'I love the colours and patterns of this painting, and the fact that it's the most abstract painting in Nathalie's work. I designed a book about Nathalie's drawings during the eighties, and she gave me this piece as a very generous thank-you.'

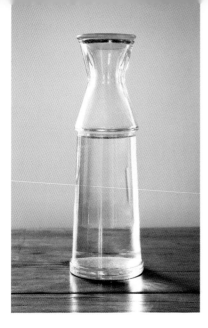

Water bottle by Nathalie Du Pasquier

'This water bottle was designed to encourage people to drink tap water in the city of Paris. Nathalie uses one at her studio, and I fell in love with it when I first saw it. It has a pretty profile, and even though I usually hate plastic objects, I like its geometry, elegance, and simplicity. I keep it on my nightstand.'

Pentadaktylos by Michael Anastassiades

'Pentadaktylos is a mountain peak in the Turkish-occupied part of Cyprus that looks like a lifted hand with five fingers. I love the weight of this sculpture and the fact it is made of solid brass. It stands on a black chest of drawers in front of my bed.'

Teapot by George Sowden

'I went to visit George Sowden and Nathalie Du Pasquier in Milan a couple of months ago and found that George was cleaning out his studio. He asked me if I'd like to keep this amazing prototype from the nineties, and obviously I said yes. Thanks, George!'

HOT SEAT

After a jam-packed day there's nothing more satisfying than reclining in your favourite chair, particularly if you're settling into a design classic. Farfetch boutique owners don't only have the finest taste in fashion, their curatorial skills extend to design. So take a seat with five of them as they discuss their most loved chairs:

LORENZO HADAR

Owner of **H. LORENZO,** *Los Angeles, California, U.S., with the Giò Ponti rocking chair*

'I love mid-century pieces, especially by Giò Ponti. I attended a vintage furniture exhibition hosted by the L.A. store **Eccola** earlier this year and bought this chair as soon as I saw it. I love its elegance, and the mixture of wood and straps.'

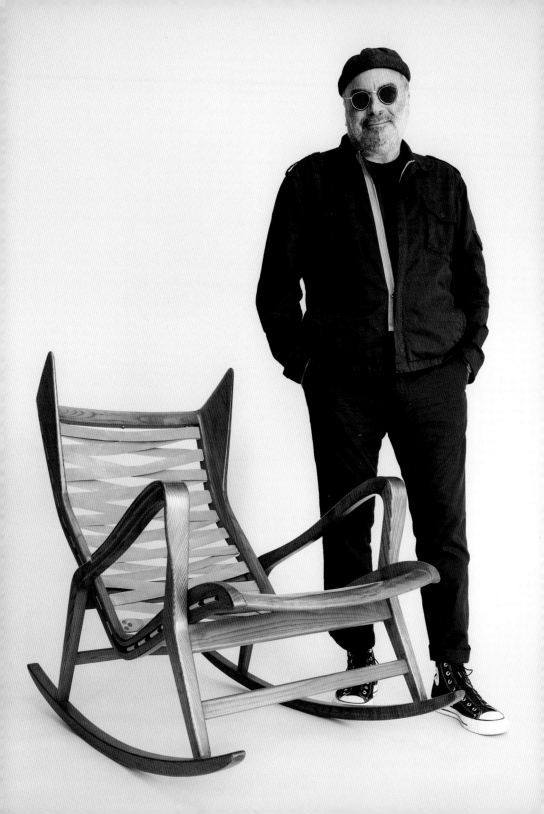

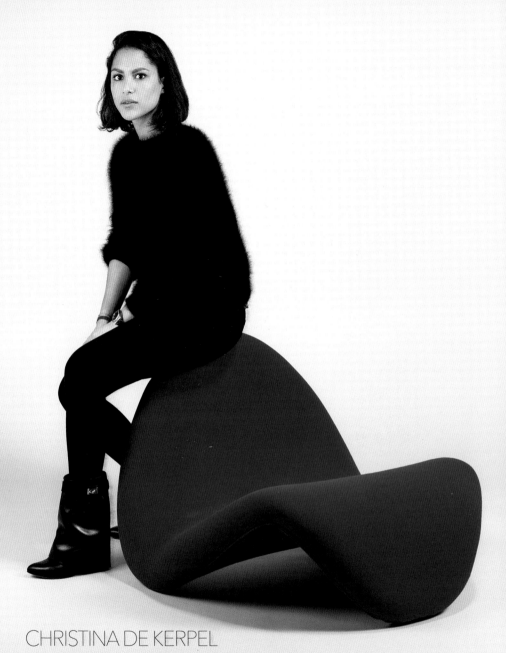

CHRISTINA DE KERPEL

Owner of **RIO STORE,** *Ghent, Belgium, with the Pierre Paulin Tongue chair*

'My husband and I have moved house a lot, but this is one piece of furniture that has followed us. The chair has a unique design and is extremely comfortable to sit in. It is now in our living room, and it has become our puppy's throne!'

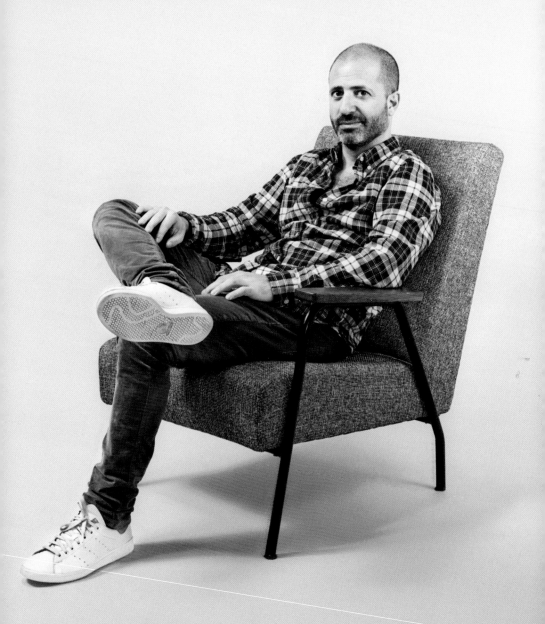

MICHÄEL MAMOU

Owner of **MODE DE VUE,** *Paris, France, with the Pierre Guariche chair*

'Taken from Guariche's 1953 CIRCA collection, this is the first piece I bought for my boutique three years ago. I love the incline of the seat.'

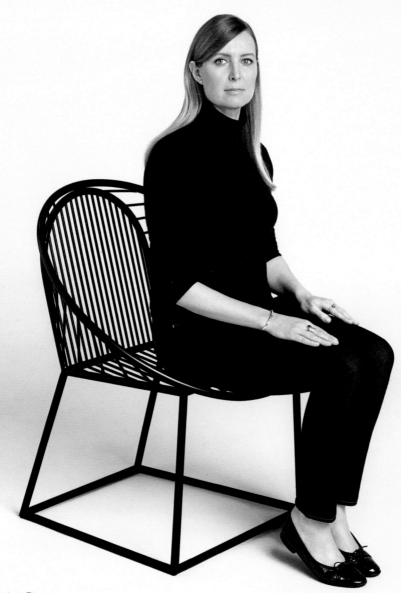

LUCY FAVELL

Owner of **URSA,** *London, U.K., with the Pool Circle chair*

'This chair is very sleek and smart yet playful, and the geometric design really grabs your attention. At first the circular shape creates an armchair form, but if you look again, you see the classic shape of a dining chair within it. I use it as a reading chair; it sits in a bay window at home.'

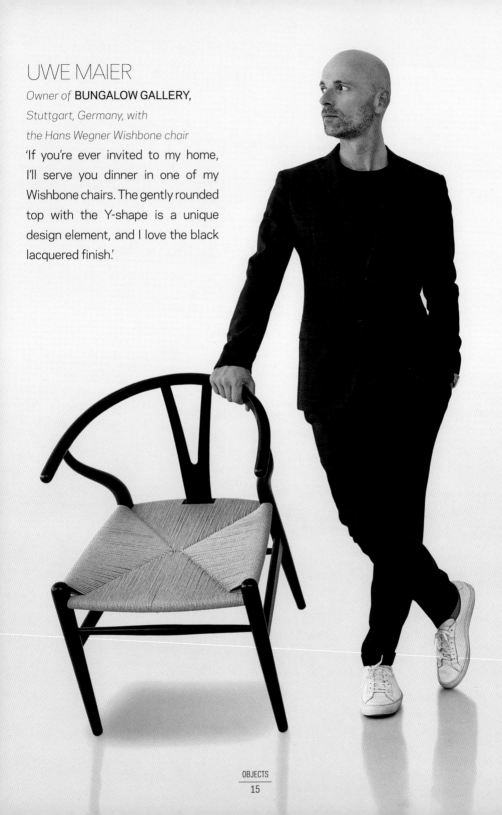

UWE MAIER

Owner of **BUNGALOW GALLERY,**
Stuttgart, Germany, with
the Hans Wegner Wishbone chair

'If you're ever invited to my home, I'll serve you dinner in one of my Wishbone chairs. The gently rounded top with the Y-shape is a unique design element, and I love the black lacquered finish.'

GO GREEN

PIET HEIN EEK AND JEANINE EEK KEIZER

Eindhoven, Netherlands

In a gargantuan studio-cum-gallery-cum-factory in Eindhoven, husband and wife duo Piet Hein Eek and Jeanine Eek Keizer create history-laden homeware from recycled materials. Well before today's upcycling boom, Piet burst onto the nineties design scene with his unique scrap-wood furniture; the Waste waste 40x40 series is made up of tables and chairs created using pixelated 40 x 40 millimetre cubes of wooden scrap material. 'Making something from nothing is my biggest inspiration,' Hein Eek explains. 'The most beauty I saw as a student was in the lumberyard.' Ceramicist Eek Keizer repurposes secondhand china using alluringly vibrant glazes. 'I feel responsible for my waste,' she says. 'I am always collecting things and going to flea markets.' This waste-not-want-not approach to creating homeware means the pair's collections, although contemporary in style, have a reassuring sense of being imbued with stories of their past lives.

DESIGN OFF THE BEATEN PATH

The world's architectural gems and design masterpieces are generally considered urban phenomena. After all, most museums and commercial and public architectural projects are located in our major cities. But that doesn't mean there aren't a few design showstoppers hidden away in the more remote corners of our planet. Farfetch tracked down four exceptional examples that are worth making a little detour to see:

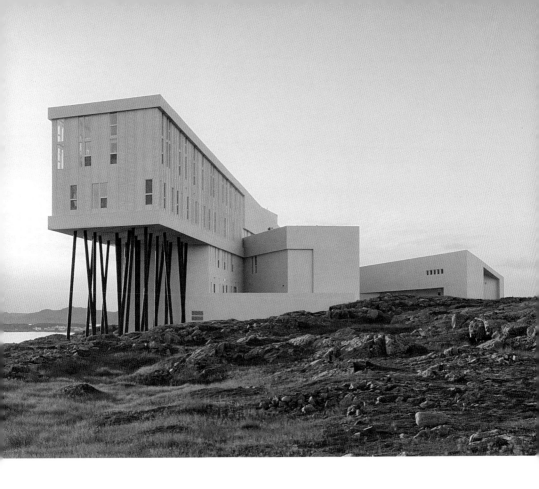

FOGO ISLAND

Newfoundland, Canada

The windswept and remote Atlantic island of Fogo has become the setting for a truly unique architecture and design project that is the brainchild of businesswoman and island native Zita Cobb. In 2001, as the island's economy declined due to its reliance on a dwindling fishing industry, Cobb established a foundation to help local people find employment. The first fruits of this were a series of artists' studios (and a residency programme) that sit dramatically in the island's wild landscape. Designed by Canadian architect Todd Saunders, all of the buildings were constructed by local people using traditional techniques. Saunders also designed the **Fogo Island Inn,** which houses furniture commissioned from international designers.

ZEN SANCTUARY
DESIGN BEACH HOME

Ilhabela, Brazil

How does a picture-perfect modernist house steps from a palm-fringed island beach off the coast of Brazil sound? Well, welcome to Zen Sanctuary Design Beach Home, a bit of a mouthful admittedly, but a super-luxe home rental that knocks spots off your average holiday let. Designed by Marcio Kogan Architects, a Brazilian practice renowned for its iconic domestic projects, the house contains a vast open-plan living and kitchen space including steps leading to the upper floor that dramatically cantilever out from the rough stone wall. Comfortable furniture in natural materials includes pieces by the likes of Brazilian great Sergio Rodrigues. The structure cleverly blurs the boundary between its interior rooms and its lush surrounds with huge retractable windows that open up to the verdant garden and rectangular pool, reinforcing the sense of living amongst the island's nature.

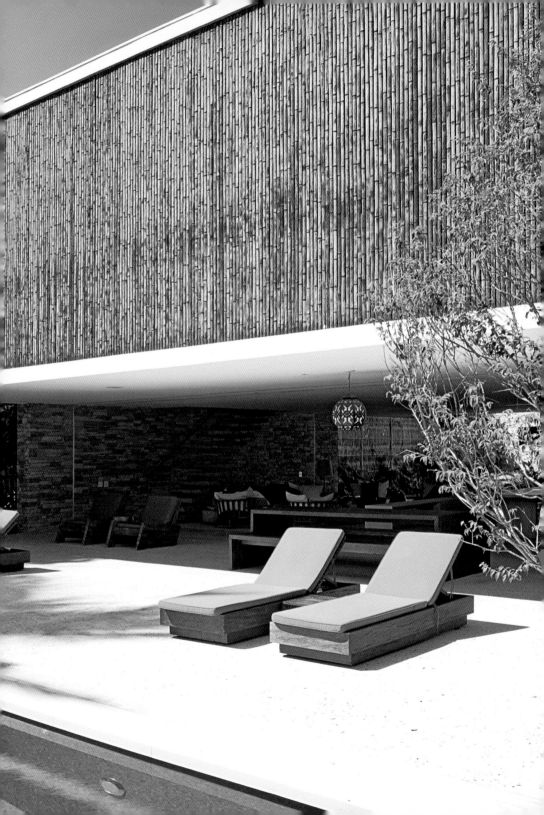

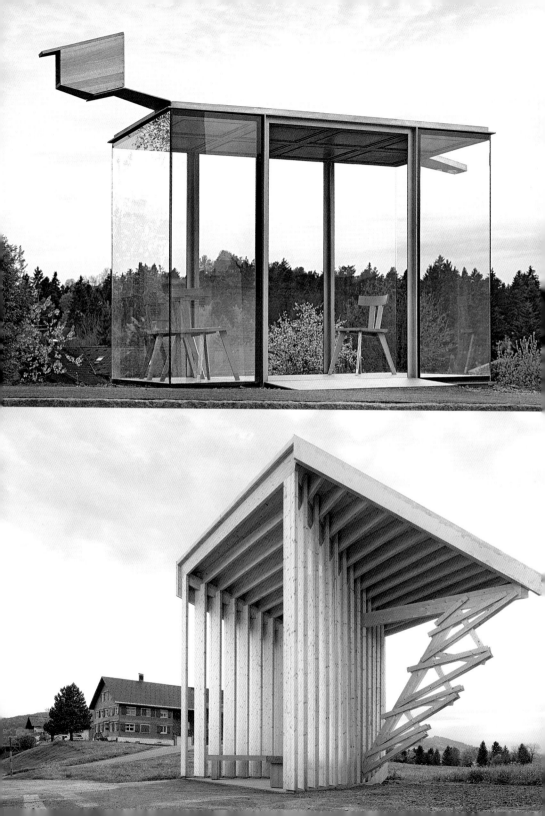

BUS STOPS
Krumbach, Austria

Waiting for a bus is not a pastime usually associated with enjoying great design, but in the small market town of Krumbach, 100 kilometres south of Vienna, the bus stops have become the standout landmarks of the area. Commissioned by the town's cultural association, the Bus:Stop project is aimed at bringing more tourists to the region, and seven international architects were each recruited to create a stop in exchange for a free holiday in the town. The result is a surprising, pleasingly diverse collection, some with shelters, that have passengers Instagramming their wait for a bus (only for three to come along at once!). Our pick: the Unterkrumbach Nord stop by Antón García-Abril and Débora Mesa of the Spanish practice Ensamble Studio, a cavelike construction of wooden planks that has a timeless presence in its roadside setting.

Below: Unterkrumbach Nord bus stop by Antón García-Abril and Débora Mesa of Ensamble Studio, Spain.
Opposite, from top: Bus stops by Smiljan Radic from Chile and Wang Shu from China.

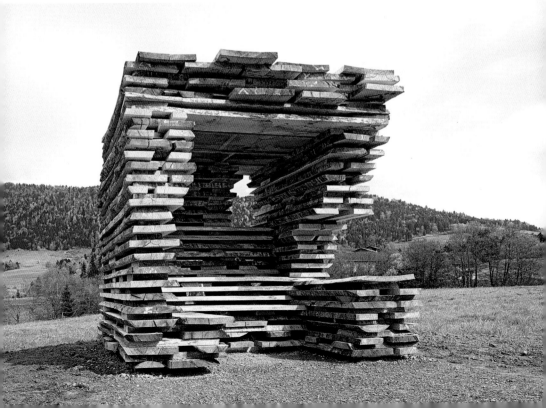

ROADSIDE LAVATORY

Akkarvikodden, Lofoten, Norway

When placed strategically on a remote Norwegian coastal mountain road, deep inside the Arctic Circle, a public lavatory not only becomes a necessity, but in this case a design destination too. On one of Norway's stunning National Tourist Routes, the basic, cabinlike block was designed by the country's Manthey Kula practice. The metal of its angular, utilitarian construction has been allowed to rust with the elements. But the stylish, geometric-themed interior is kept dry, warm, and clean by its windowless design and interior glass panels. Never has a visit to the restroom felt like such an event.

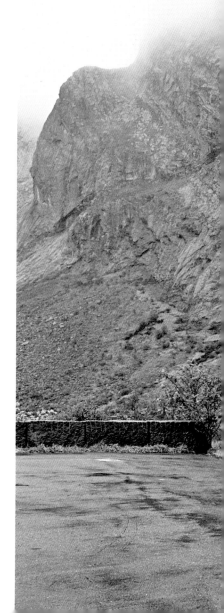

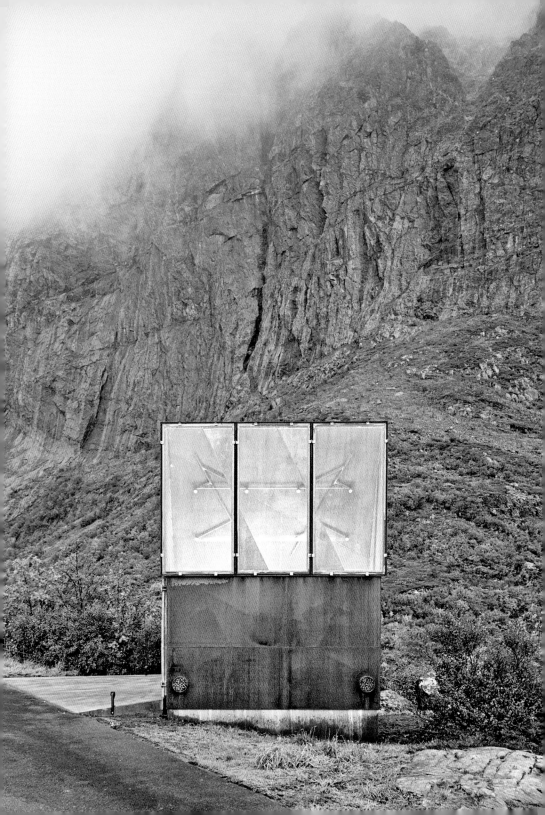

SPOTLIGHT: TAIPEI

The balance of financial influence is shifting around the world as new economies power up. So too is the balance in the world of design. With Asia becoming of rapidly increasing importance, Farfetch asked Dan Howarth, design editor at influential online magazine *Dezeen,* to tell us why the Taiwanese city of Taipei is emerging as a go-to for innovative design:

The design spotlight is almost ready for Taipei as it waits anxiously in the wings to perform its lead role as World Design Capital in 2016. While the audience waits with bated breath, I'd forgive them for not recognising many of the names listed in their programme; the Taiwanese capital is better known for its electronics production than its craftsmanship. However, as the city is determined to host events and secure titles, such as the World Design Capital designation, that will promote the creative industries, this is all about to change.

But how will Taipei's cast of creatives bring its design to the global stage? First stop: Remove the need for subtitles. Graphic designer ShaoLan Hsueh has transformed the approach to picking up Mandarin by combining Chinese pictograms with images of their English equivalent. Her *Chineasy* book is a simple, colourful, and, as the title suggests, easy way to help memorise those tricky lines.

Hsueh is one of many Taipei designers who are adapting elements of their cultural heritage into new characters, creating a new minimal style that has already gained international success.

ShaoLan Hsueh.

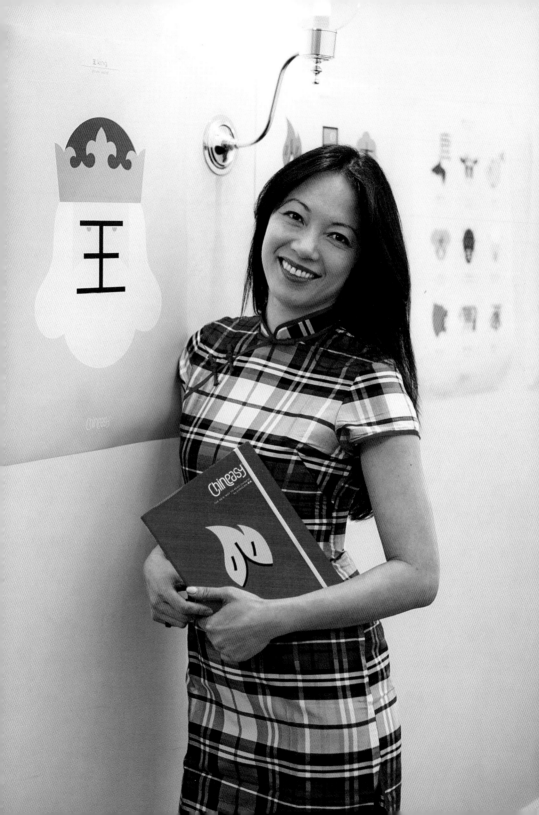

Kenyon Yeh and Bria, part of his UNIKEA project. *Opposite:* Yeh Wall Table by Kenyon Yeh.

Furniture designer Kenyon Yeh's pared-back pieces certainly gained rapturous applause from Danish furniture brand Menu, which now produces his two-legged Yeh Wall Table that props neatly against any vertical surface. Like many stars, Yeh has also started working behind the scenes. His company **Esaila** partners with local and international designers to enable their contemporary furniture, lighting, and accessories to be produced in Taiwan.

Another Scandinavian favourite is Yenwen Tseng, a graduate of Stockholm's Konstfack – University College of Arts, Crafts and Design, who creates equally simple yet sophisticated furniture that will soon gain him a slice of the limelight.

Other designers are steering clear of blockbusters and sticking to low-budget indies, with just as effective results. Take research lab **Fabraft**, which has kitted out a standard bicycle, a staple on the city's streets, with a computer and a 3-D printer that's attached to a frame on the front. Aiming to bring this innovative technology to the masses, the studio's Mobile Fab is equipped to recycle unwanted plastic cups into new products right in front of curious spectators.

Thanks to the technology industry, Taipei's burgeoning economy has also had a profound impact on its skyline's stage presence. In 2004, the city's architecture made the front pages of the world press when the **Taipei 101** skyscraper rose up

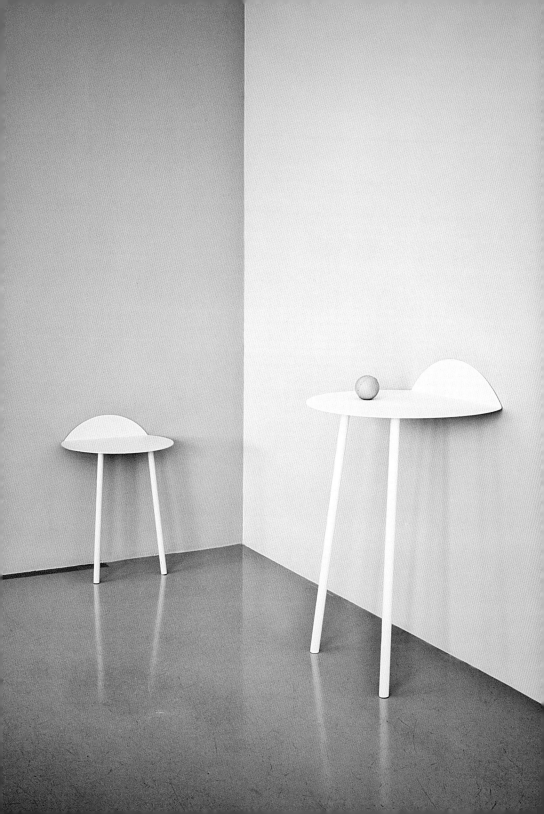

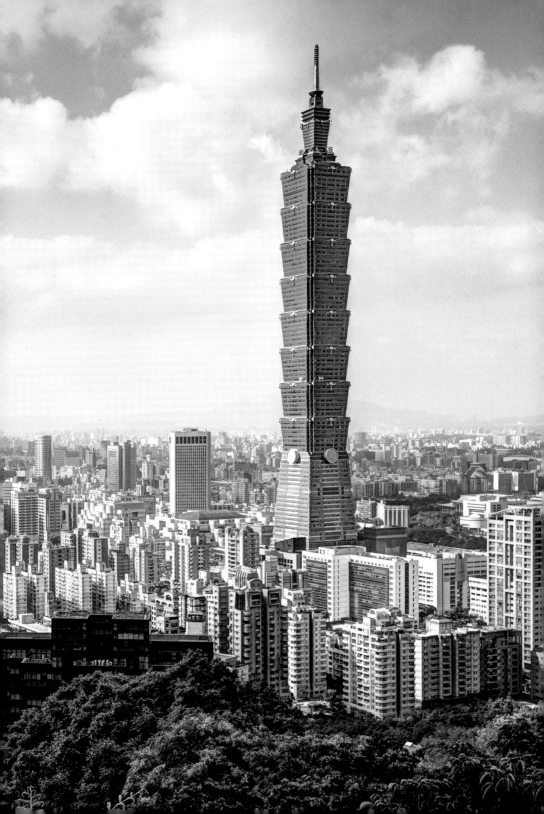

over half a kilometre from the relatively low-rise urban surrounds to become the world's tallest building – a title it held until surpassed by Dubai's Burj Khalifa in 2010. Designed by local architects C.Y. Lee & Partners, the structure acted like a 508-metre-high pin on the map for the city – which has since commissioned a series of high-profile buildings.

Other landmark construction projects have been announced around Taiwan, namely in Taichung, with buildings by A-listers that include Danish innovator BIG, Japanese maestro Toyo Ito, and American heavyweight Richard Meier. But back in the capital, all eyes are firmly on Dutch architecture studio OMA's landmark **Taipei Performing Arts Centre,** which, from the street, looks as though a giant ball is colliding with the building's facade – irrefutably dramatic. The venue, which is nearing completion, will boast a layout that will allow its three theatres to be used in various combinations and configurations, accommodating groundbreaking performances.

The stage is almost set for Taipei's designers to hit the big time. They have the talent, the technology, and, most important, the big break to put their names in lights. Better snap up those tickets now; it's going to be a sellout.

Yenwen Tseng and his Handlebar Candlestick. *Opposite:* The Taipei 101 Skyscraper.

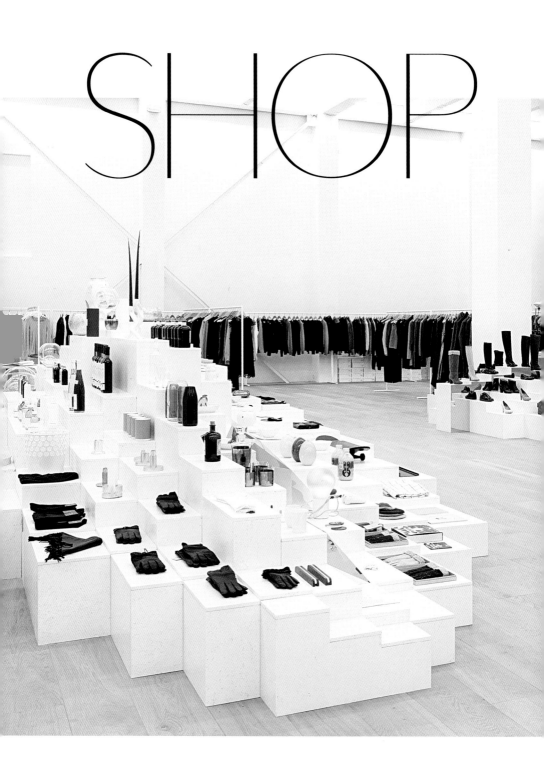

SHOP

STYLE

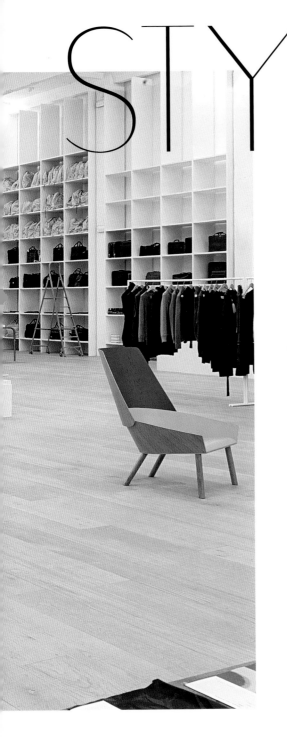

From the shores of Newport Beach to the streets of Berlin, we present the world's most masterfully designed Farfetch boutiques:

ANDREAS MURKUDIS

Berlin, Germany

More like a museum of affection than a shop, with its regimented rows of luxurious gems by Maison Margiela and Nymphenburg, Andreas Murkudis is housed in the former printing and packaging halls of the *Tagesspiegel* newspaper building. The capacious 1,000-square-metre space, illuminated by strip lighting with a gallery-like monochrome colour scheme, was designed by architects Gonzalez Haase and is the ultimate location in which to experience Berlin's minimalist-industrial aesthetic.

ALCHEMIST

Miami, Florida, U.S.

Suspended sixty feet above the Miami Beach skyline, on the fifth floor of a Herzog & de Meuron-designed car park, sits Alchemist. Created by owners Roma and Erika Cohen and architect Rene Gonzalez, this transparent cube is composed of mirror and glass, reflecting the chaos and colour of Alton Road below. As the urban landscape appears like a mirage reflected above you, browse international luxury labels like Rodarte and Givenchy. Just don't leave your credit card at home; the car park exit is a long way down!

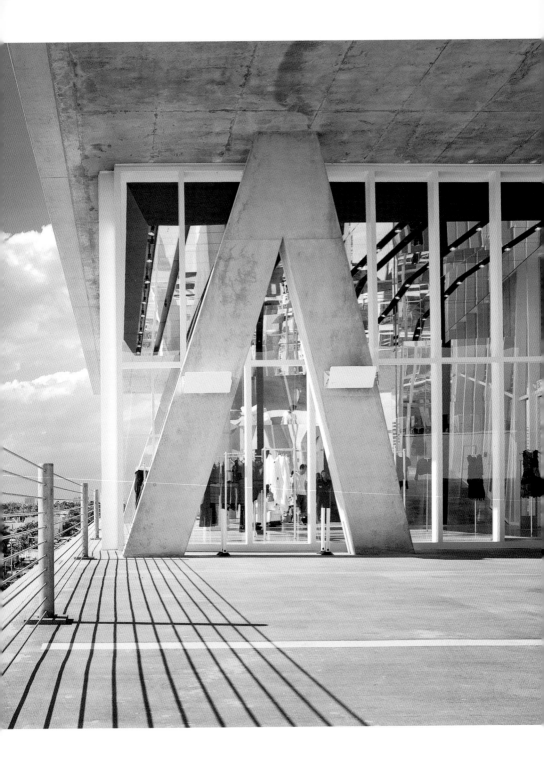

CAHIER D'EXERCICES

Montreal, Canada

The punctured black metal walls, stark white shelving, and imposing red columns of Montreal's Cahier D'Exercices capture all the hallmarks of industrial Russian Constructivism. No surprise therefore that the boutique is housed in the former Ross warehouse store, a nineteenth-century stalwart in the production of fur and leather. Designed by Saucier + Perrotte Architectes, and stocking alluring brands from Marni to Maison Michel, the store boasts a gradient-effect ceiling and secret changing rooms – the ideal location for staging a revolution of your own.

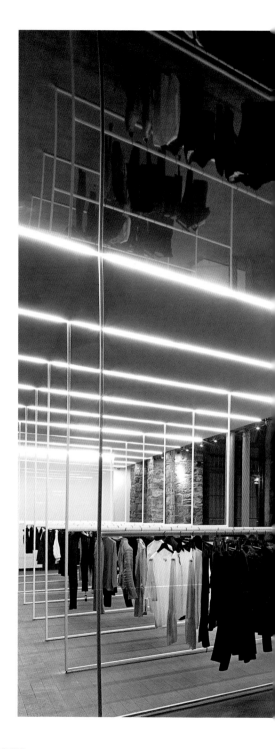

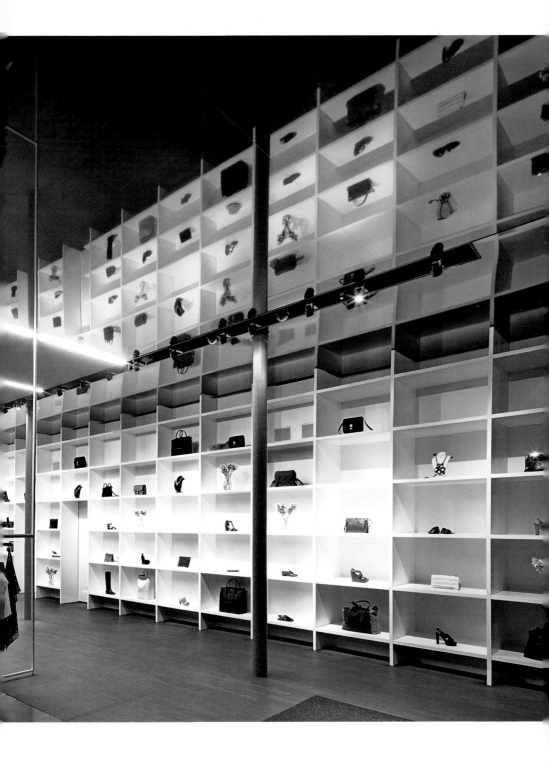

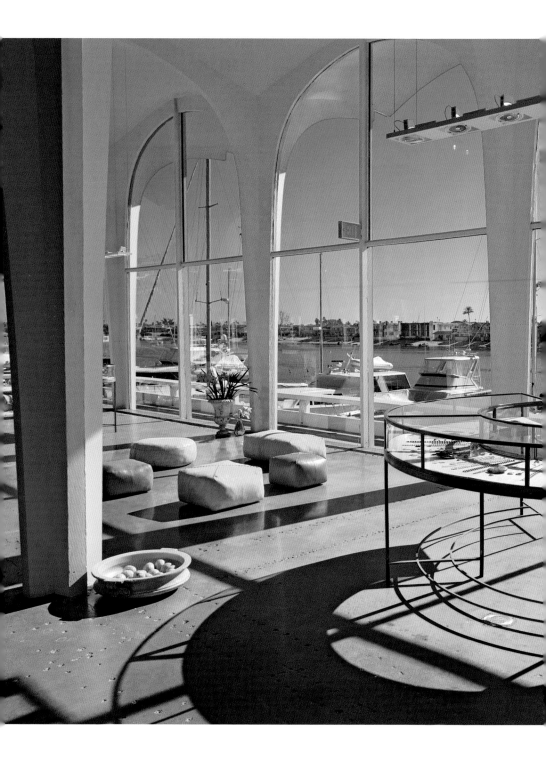

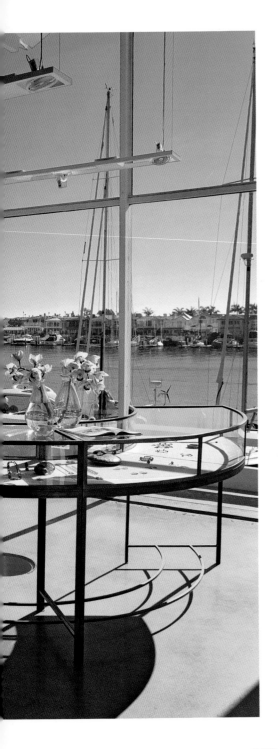

A'MAREE'S

Newport Beach, California, U.S.

The undulating roof of this sixties masterpiece mirrors the curling profile of the waves that lick the shore near A'maree's boutique, designed by Thornton Ladd and John Kelsey. Glass portholes in the floor mean you can stare into the depths of Newport Harbour, while soaring, arched windows provide idyllic panoramic views. After stocking up on timeless silhouettes from The Row and The Elder Statesman, you can even depart in style: A'maree's has its own boat slip.

THE NEW DESIGN CAPITALS

What makes a city a design capital in the twenty-first century? Which will emerge this year and beyond? Farfetch asked *Monocle* magazine's Tom Morris, one of the world's preeminent authorities on the subject, to share his expert view:

There are many components to a city becoming a true design capital – designers, naturally, not to mention good graduate-level education, and retailers and festivals to support and inspire them. Any design centre relies on a strong infrastructural framework to give its creatives the help they need with manufacturing, marketing, and investment. As the design industry becomes an increasingly fruitful business, plenty of cities are investing in their design communities – we are losing track of the new design weeks being launched each year (Liverpool Design Festival, anyone?). So here are my tips on the real destinations to watch for in the months and years ahead.

DUNDEE
Scotland, U.K.

Yes, it may come as a surprise, but Scotland's fourth-largest city will be making design headlines over the next few years. Ground will soon break on the **V&A Museum of Design, Dundee,** a waterfront building masterminded by Japanese practice Kengo Kuma & Associates, and the U.K.'s first design museum outside of London. The building will take years to complete, but Dundee's position as a design capital was also recently confirmed by UNESCO. In late 2014, it recognised the metropolis as a City of Design, the first city in the U.K. to be awarded the title. Plenty of design innovations have been made in Dundee including – and we'll trust UNESCO on this one – comics, video games, and orange marmalade.

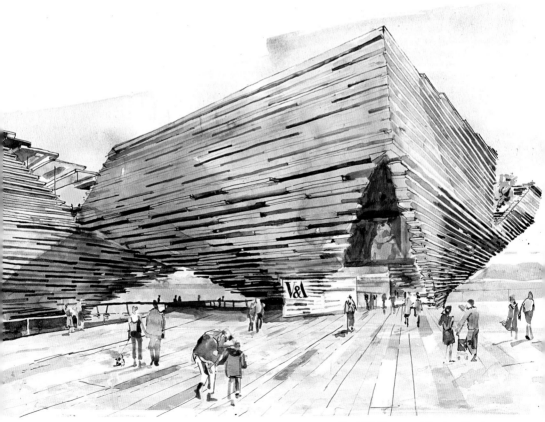

The V&A Museum of Design, Dundee.

JAKARTA
Indonesia

Like those of Bangkok and Taipei before it, the craft and design community of the Indonesian capital is finally learning to celebrate its manufacturing prowess and step out of the shadows. 'Made in Indonesia' is becoming an increasingly exciting stamp of approval, and there are plenty of designers to watch. My favourites are **Karsa** – a young furniture studio that produces collections made from traditional Indonesian materials such as teak and rattan, with a gentle touch of Scandinavian simplicity – and the elegant pieces by **AlvinT** are also an Indonesian strength. Jakarta-based practices **SUB** and **Aboday** do a mean turn in tropical modernism.

The Karsa Studio team: Joshua Simandjuntak, Fachril Fathiansyah, Irma Febriani, and Diaz Adisastomo.

PRAGUE
Czech Republic

There are plenty of claims to the throne of Eastern Europe's most exciting design hub – Lodz and Warsaw in Poland, for instance, not to mention Bucharest, Romania – but it is undoubtedly Prague that most deserves the world's attention. Designblok, the design and fashion week held each October, is a rewarding place to seek out fresh talent. Maxim Velčovský (now art director at the legendary glassmaker **Lasvit**) and Lucie Koldová (a Paris-based designer who works extensively with Czech manufacturers such as Lasvit and **Brokis**) are my local favourites. Prague's position as a design destination has also been cemented by a host of retailers (**Gallery Křehký** is great for contemporary pieces; **Nanovo** for Soviet-era gems) and hotels (**Hotel Josef** and **The Emblem Hotel** are the best looking).

The Lasvit Glass showroom.

MIAMI
Florida, U.S.

With boulevard after boulevard of Art Deco masterpieces, Miami's position as a world-class architectural hub has long been cemented. That looks set to continue in the coming years with Zaha Hadid and Foster + Partners both working on big builds in the seaside city. However, Miami's clout as a design capital is strengthening year by year too. In 2014, Design Miami celebrated its tenth anniversary: a decade of myriad blockbuster, eye-grabbing exhibitions, not to mention hosting some of the design world's best parties. But Miami has always struggled to be seen as a commercial capital - not just a creative folly – of the design industry. How much business is actually done there? How many orders are made? That looks set to change with Maison&Objet, the eminently important biannual trade fair, which hosted its first Americas edition in the city in May.

Zaha Hadid's 1000 Museum condo building.

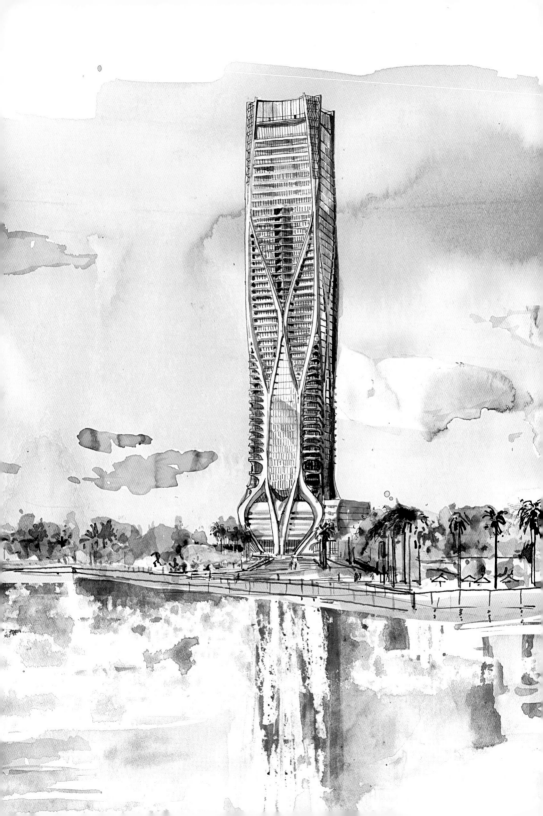

DUBLIN

Ireland

This year is set to be a big one for Éire, as the nation celebrates Irish Design 2015, a worldwide, yearlong programme of events and exhibitions hosted by the Design & Crafts Council of Ireland. It aims to showcase the best of the nation's contemporary design and craft, monopolising on increasing momentum in Irish-made products. The rejuvenation of cut-crystal glass manufacturer **J. Hill's Standard** was one of my highlights at 2014's Salone del Mobile furniture fair in Milan (especially its stellar collaboration with Dutch studio Scholten & Baijings); and **Makers & Brothers** – the Dublin-based vendor of Irish design, including Mourne Textiles and woodworker James Carroll – remains one of *Monocle*'s favourite retailers. The second half of this decade should see the Emerald Isle sparkle more than ever.

Record room divider by James Carroll.

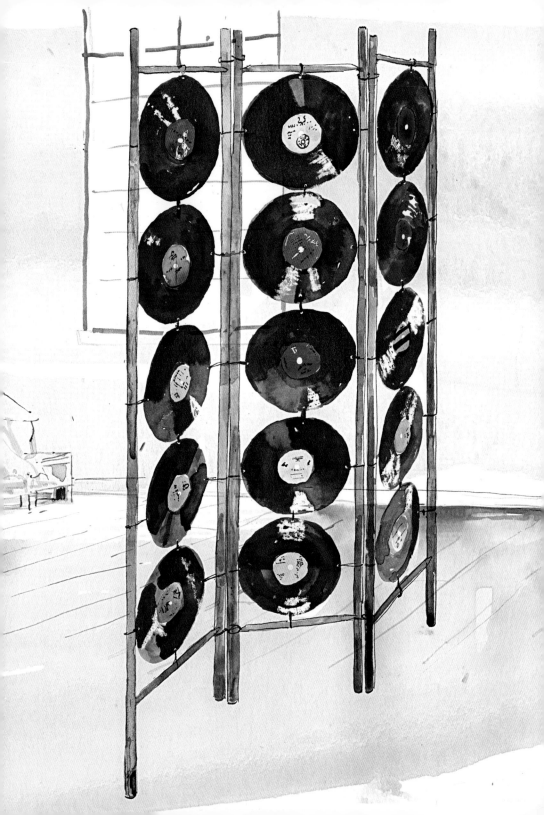

GO GREEN

CALIFORNIA ACADEMY OF SCIENCES

San Francisco, California, U.S.

Green thinking is at the very heart of San Francisco's California Academy of Sciences. Designed by Renzo Piano and completed in 2008, this natural history museum, which replaces the earthquake-damaged original, has been designed from the ground up to be as environmentally low impact as possible. Constructed almost entirely from recycled concrete and steel with insulation provided by shredded recycled denim, the pioneering building sits beneath an undulating living roof, sown with an assortment of native plants and grasses and irrigated with collected rainwater. Electricity is generated from solar panels but, in 90 percent of cases, natural daylight illuminates the interior. The museum's understated but futuristic looks are indicative of a building that represents the architecture of the future.

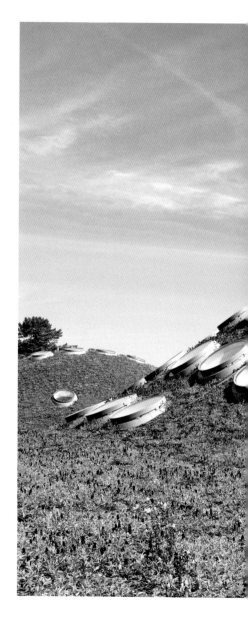

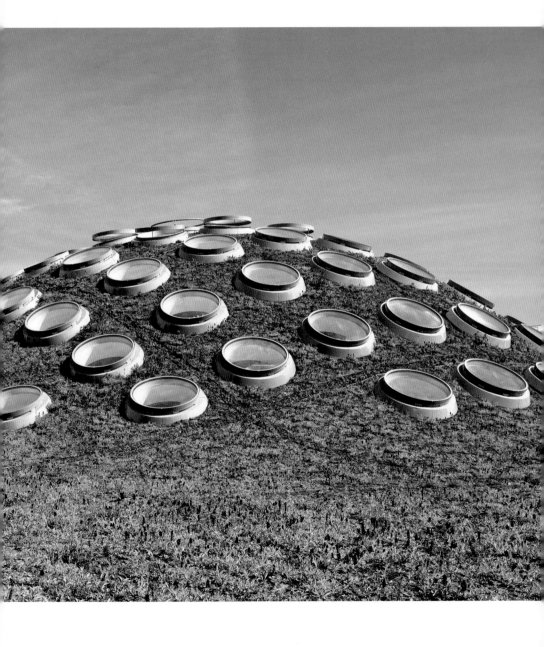

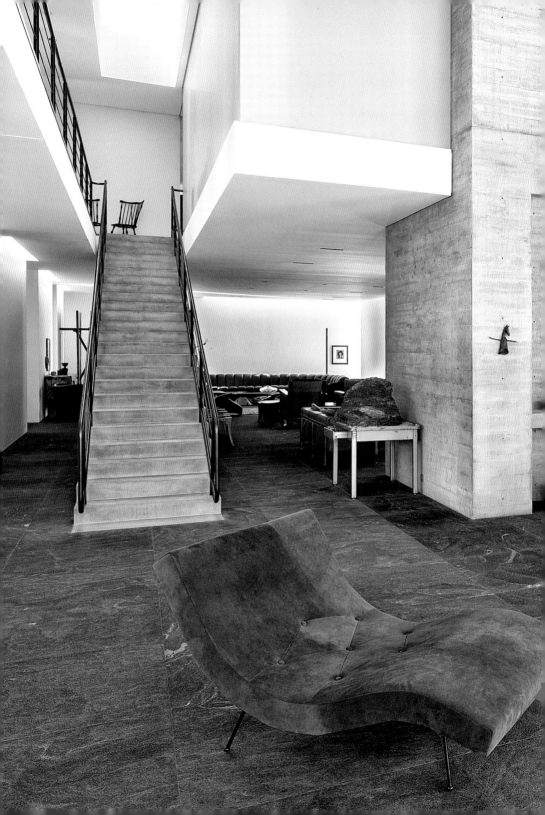

OPEN
HOUSE

From a Scandi-centric haven in Berlin to a brutalist concrete cube in Michigan, the homes of Farfetch boutique owners and buyers demonstrate a passion for incredible design that extends far beyond the walls of their stores. Here, we get a rare glimpse into their private habitats, which – from Zaha Hadid chairs to an Ettore Sottsass vessel – teem with must-see treasures:

LINDA DRESNER

LINDA DRESNER BOUTIQUE, *Birmingham, Michigan, U.S.*

'It took four years of planning and three years to build,' explains Linda Dresner, speaking of her 7,200-square-foot minimalist concrete home. Designed by architect Steven Sivak, its exterior is built with self-consolidating concrete and self-oxidising steel plates. A limestone totem pole sits in the garden, and a slit in the hidden front entrance remains open to the clouds. Renowned for the daring buys in her eponymous Michigan boutique, Dresner's interior style is equally diverse. 'I buy what speaks to me,' she says, 'which is varied, with no rules.'

Two-piece wooden tower by Susan Wood, stainless-steel desk by Maria Pergay.
Previous pages: Forties suede lounger, a present from the late designer J.W. Fred Smith; horse sculpture by Daisy Youngblood; painting in alcove by Ad Reinhardt; black-and-white painting by Al Held.

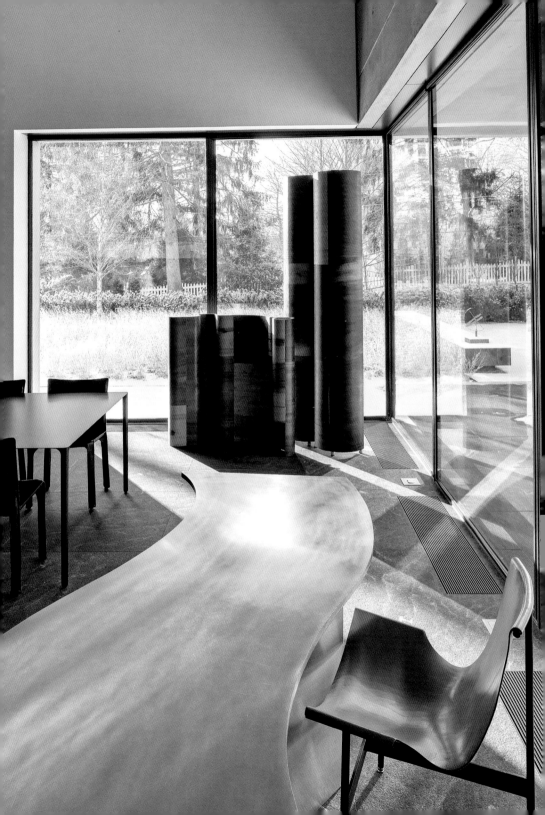

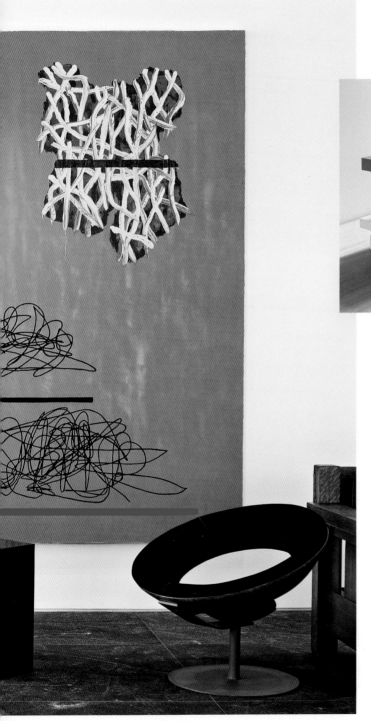

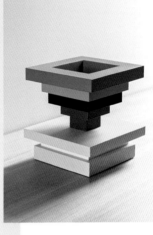

Painting by Jonathan Lasker, *Donut* chairs by Ricardo Fasanello, orange wire sculpture by Leon Dickey, black steel sculpture by Tony Smith. *Above: Geology 8* by Ettore Sottsass. *Following pages, from left:* White African ceramics by Astrid Dahl, painting by Josef Albers, black box by Yayoi Kosama; paint table sculpture by Scott Richter. *Pages 60-61: Picnic Table* standing sculpture by Forrest Myers, carbon fibre *Surface* table by Terence Woodgate and Maria Pergay, curved leather sofa by de Sede, *Detroit* crushed metal coffee table by Fredrikson Stallard, blown glass piece (on coffee table) by Ritsue Mishima, vintage rug.

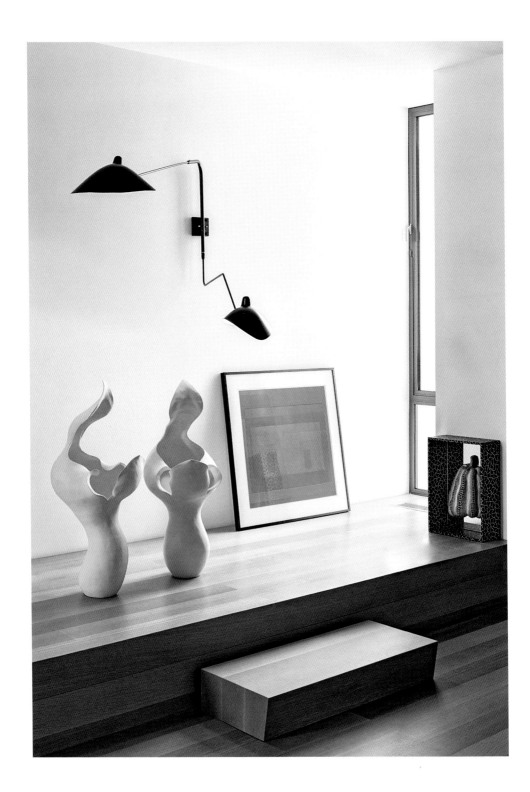

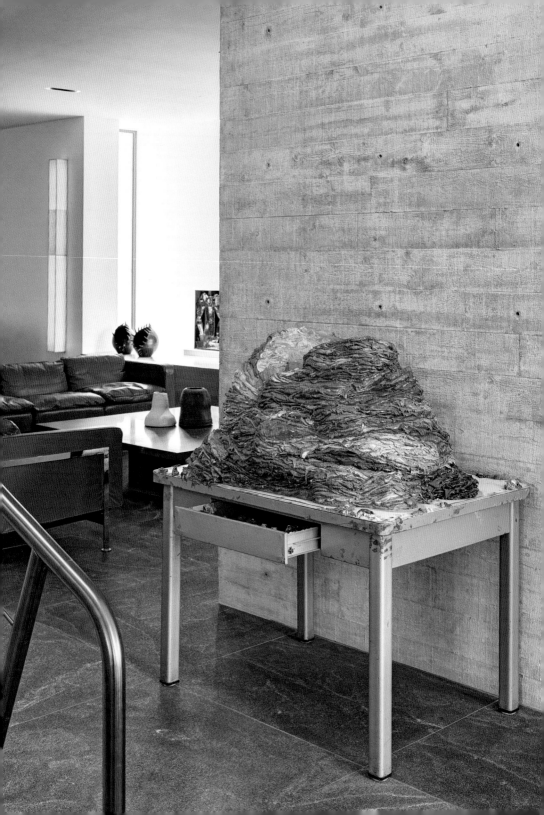

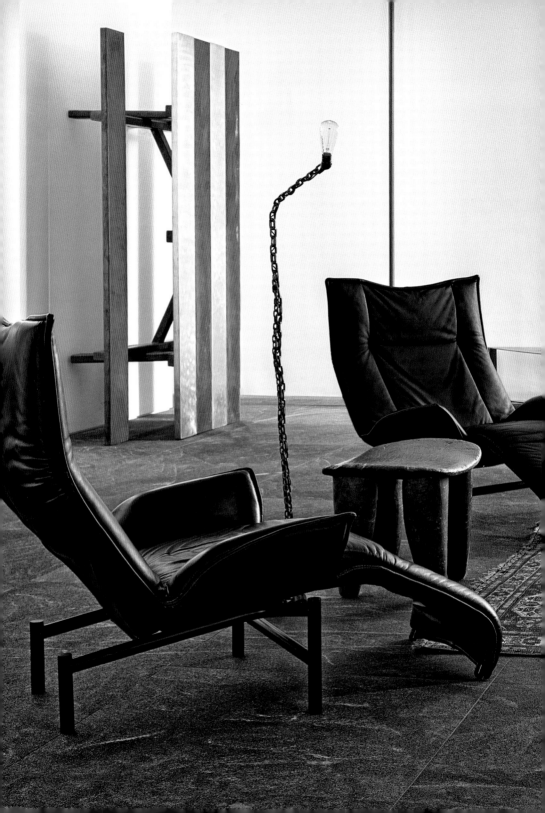

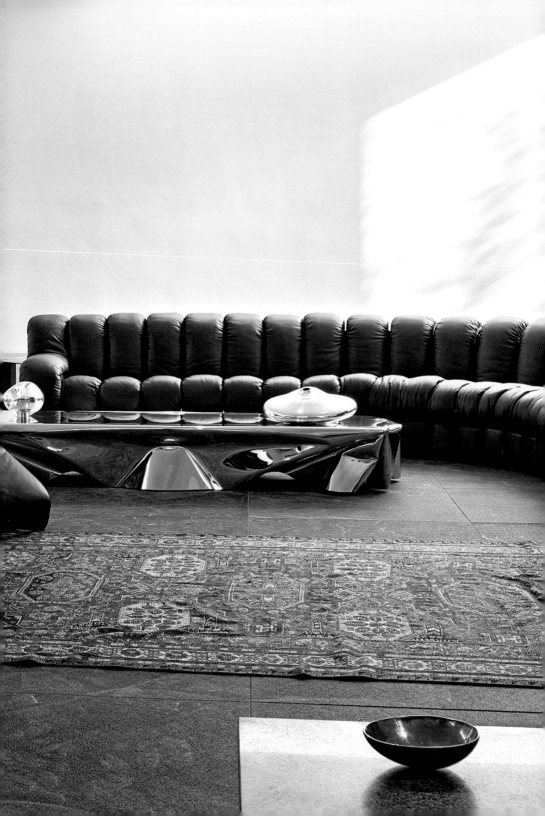

HERBERT HOFMANN

VOO STORE, *Berlin, Germany*

'Bright, cosy, and green' is how Herbert Hofmann, creative director and buyer of the Berlin-based boutique Voo, describes his leafy and minimalist Kreuzberg apartment. Amidst orchids, air plants, and bonsai trees sit furniture prototypes created by his Danish designer boyfriend, Sigurd Larsen. 'We moved in six years ago because we fell for the bright rooms and rooftop views,' Hofmann smiles. 'Plus, I love Scandinavian design, so it's a perfect match.'

Handmade table, candle from Succulents in Brooklyn, New York, eighteen-year-old bonsai tree, illustration by Jakob Tolstrup, Holmegaard Pharmacy's lamp.

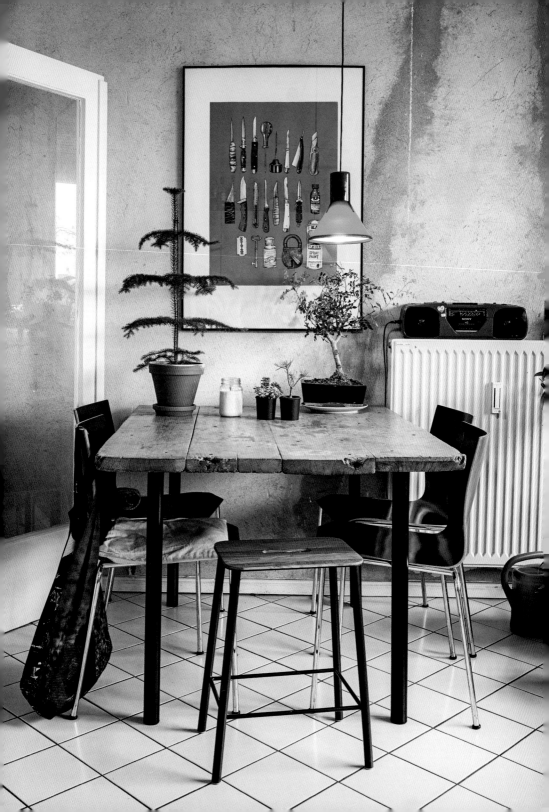

Clockwise, from top left: Shelving by Sigurd Larsen Design.
Bed handmade by Hofmann's brother-in-law, blanket by Nike x
Pendleton, pillowcase by Henrik Vibskov, paper lamp from an Asian
supermarket. 'S' from a PR event. *Der Aufstieg* painting by Tyrolean
architect and artist Alfons Walde, chair in an old Danish supermarket
design now reintroduced by HAY. *Following page:* Table and shelf by
Sigurd Larsen; hanging succulents, palm trees, and evergreens; and
what Hofmann dubs, 'a telescope I can use on the roof.'

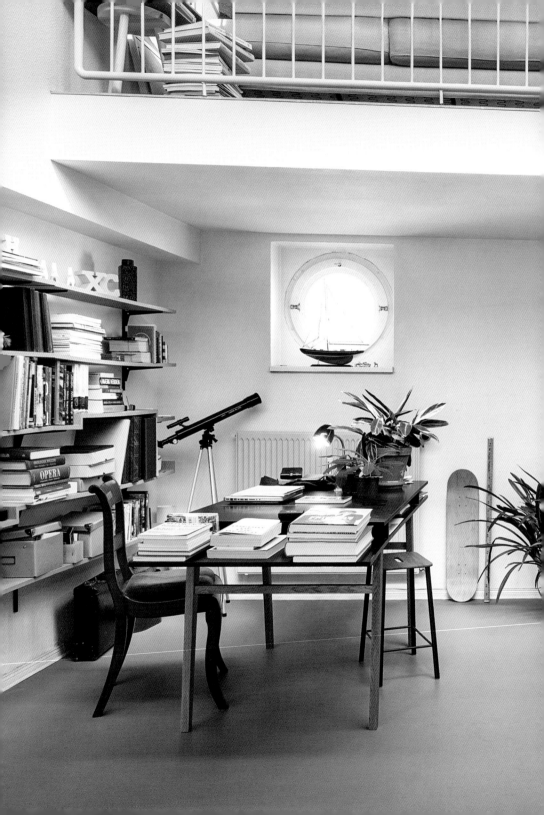

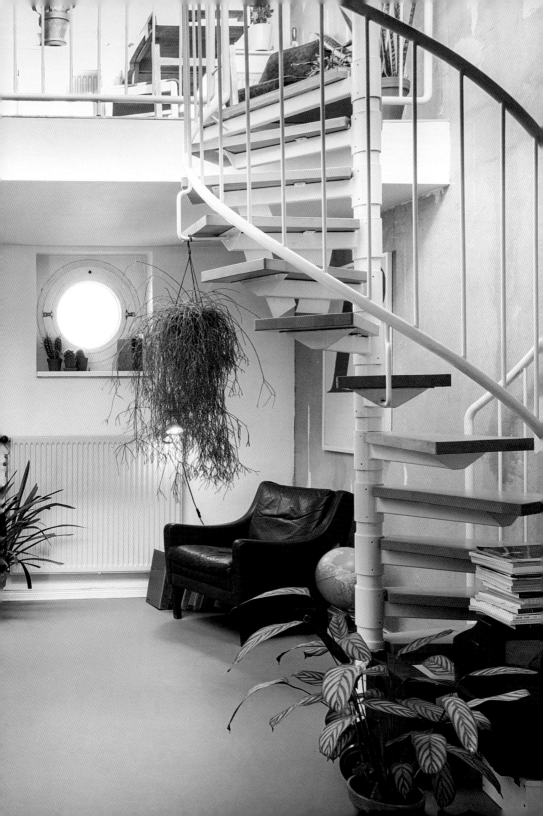

ARMAND HADIDA

L'ECLAIREUR, *Paris, France*

'Our home isn't inspired by anything that exists; there's no code, no rule, but there is an equilibrium in the disorder,' explains Armand Hadida, owner of the renowned Parisian boutique L'Eclaireur. Nestled in the French capital's eclectic Marais district, Armand's home, formerly owned by the aristocrat Madame de Sévigné, once housed pieces now displayed in the Carnavalet museum. Today, it boasts intergalactic-looking Zaha Hadid furniture and nineties tableware by William Sawaya. 'Our pieces are very motley,' Armand says. 'They each found their own place in our home spontaneously.'

Painting by Thomas Fougeirol, *Simon* candlestick by Borek Sipek, *Vanité* skull by Stéphane Olivier. *Following pages:* Spanish upholstered sofa, vintage mirror, chair (left) by Zaha Hadid, Syrian chair (right) with mother of pearl inlay, vintage chest of drawers from a ship. *Page 72:* Custom-made library, vintage stool and drum, fifties Italian lamp. *Page 73:* Vintage head sculpture and collection of Chinese calligraphy brushes.

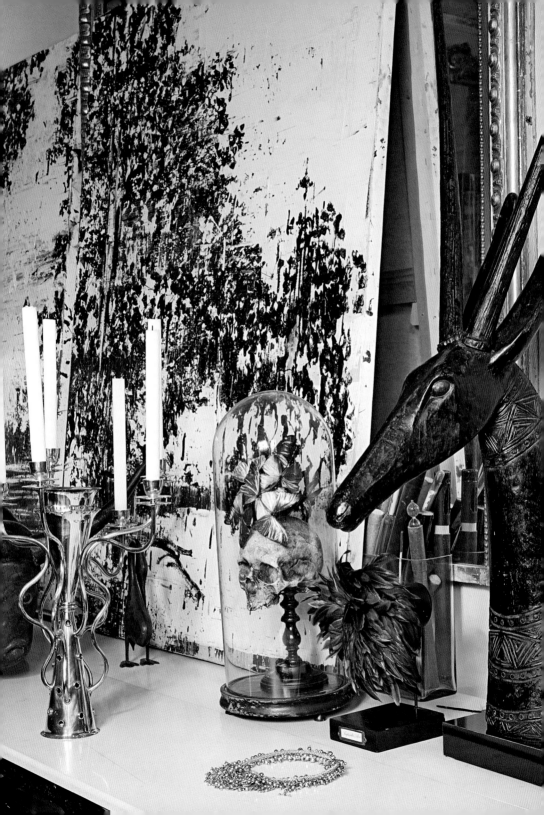

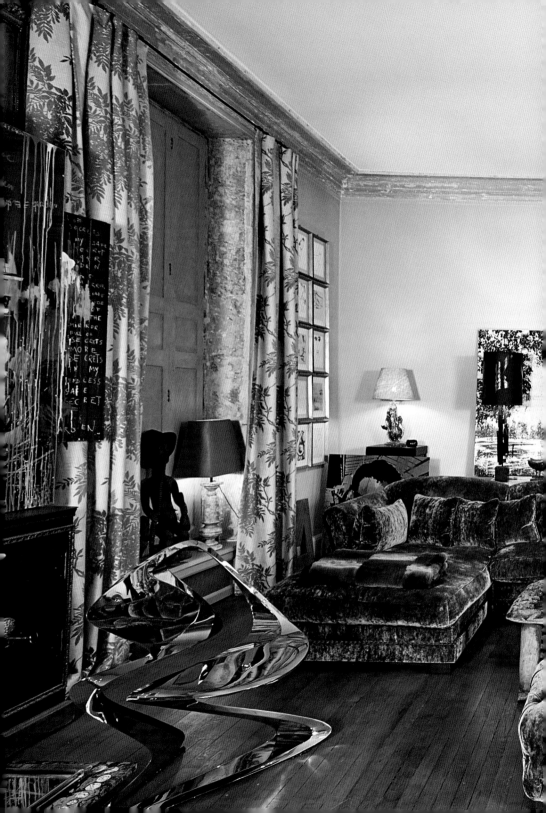

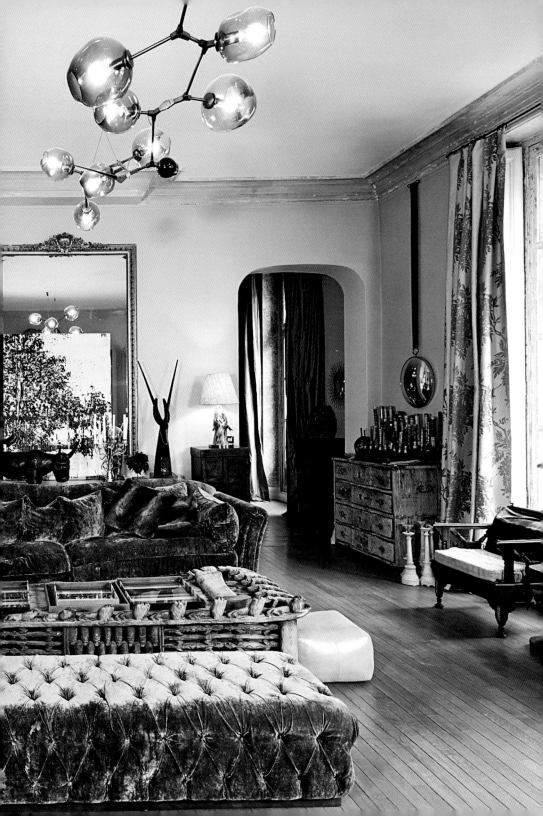

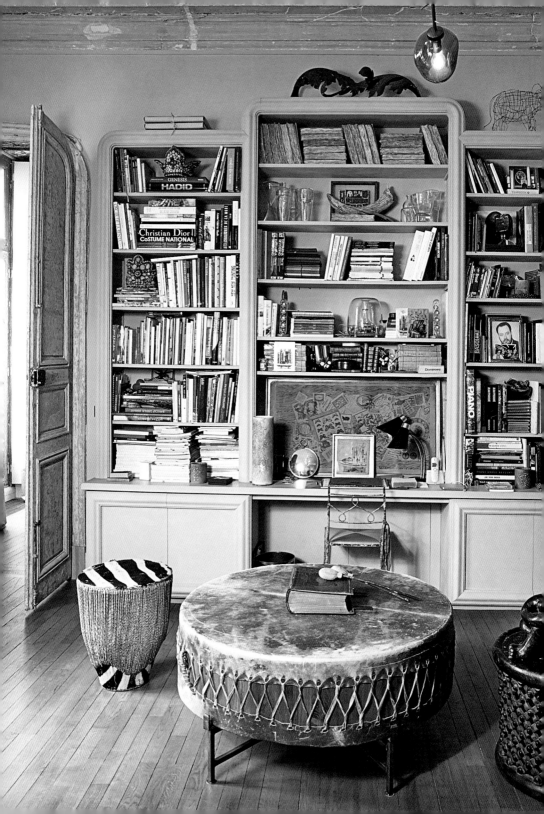

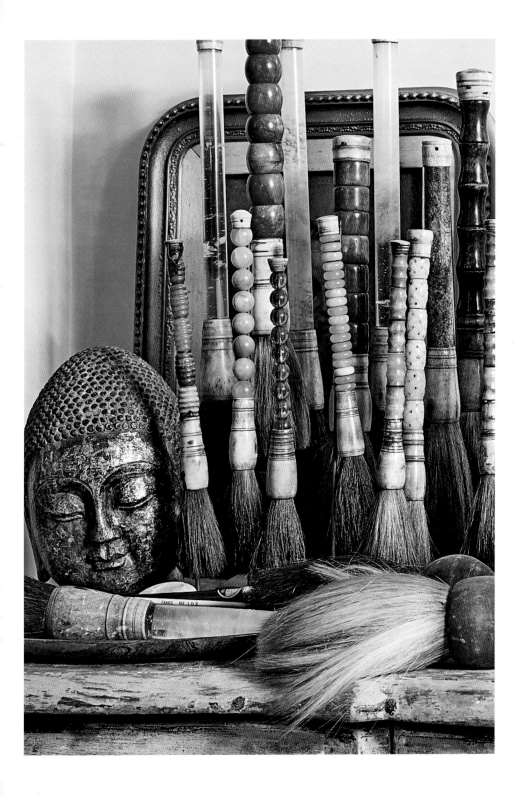

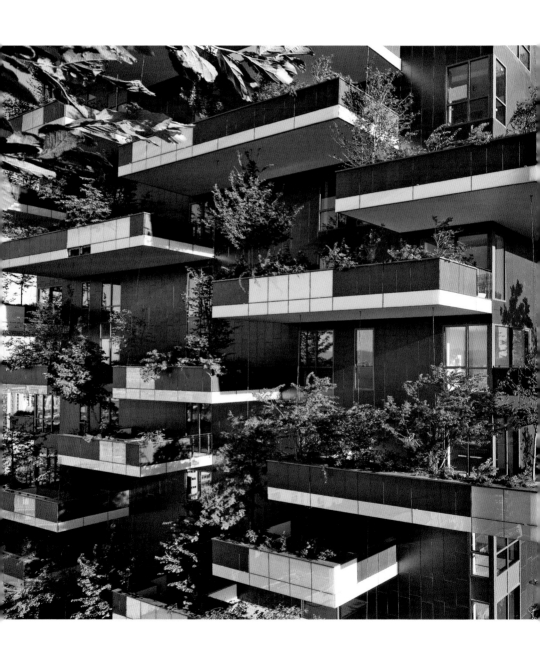

GO GREEN

BOSCO VERTICALE
Milan, Italy

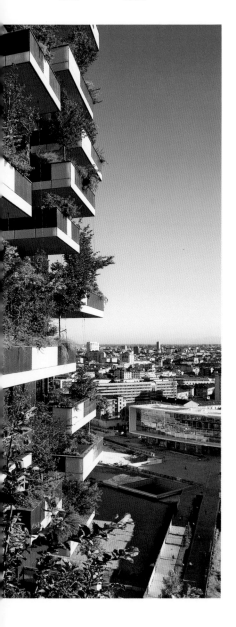

Bosco Verticale is a twin-towered residential complex recently completed in Milan. The work of architect Stefano Boeri's practice, it is designed to take a new approach to city living with a genuine environmental focus. So not only does it literally look green – the name translates as 'vertical forest' and the protruding balconies on every level are stocked with over a thousand different species of tree and plant – the way the building functions is green in principle too. These sky gardens are designed to fill the immediate atmosphere with oxygen, filter out carbon dioxide, and protect the living areas from air and acoustic pollution, wind, and sunlight. They're also irrigated by wastewater from the building itself. All parking areas and roads into the complex are underground, freeing up space around the towers for even more foliage and a cycling area. With four hundred apartments in the towers, Bosco Verticale represents the first baby steps in a wider project to turn Milan into a far less polluted city.

HOTEL
HOTSPOT

Considered to be the most American of America's cities, Chicago is known for its association with music, organised crime, and, famously, its adventurous architecture. An expert on the merits of the city, *Wallpaper** magazine's Lauren Ho explores the latest revolution in Chicago's burgeoning hotel scene:

The big-city ambitions of Chicago – once a rival to New York – were eclipsed by the Big Apple's lofty commercial drive and the glitter of Los Angeles. However, the Great Chicago Fire of 1871, which destroyed 3.3 million square feet of the area, gave the city a chance to rebuild itself as a dynamic metropolis and, at the same time, entice architects – including William Le Baron Jenney, Daniel Burnham, and John Wellborn Root – to contribute to the urban landscape we know today.

In recent years, there's been a subtle shift in the city's dynamic, with a new wave of hotel projects transforming the industry. It started with the 2013 launch of **The Langham** in architect Ludwig Mies van der Rohe's celebrated IBM Building. Since then, a slew of Chicago's most architecturally notable buildings have been transformed – or earmarked for renovation – into luxury hotels.

Soho House, the private members club that launched two decades ago in London, has built a reputation on retooling mostly retired industrial warehouses. Its Chicago outpost is no different. Located in the city's Fulton Market area, the hotel occupies the Allis Building – a handsome five-storey, reinforced-concrete hulk with a red brick façade. Built in 1908 for the Chicago Belting Company, the forty-room property has been altered to comprise a series of social spaces, a now signature rooftop pool, and, paying tribute to the city's pugilistic roots, a 17,000-square-foot gym equipped with a state-of-the-art boxing ring.

With demand for commercial real estate in Chicago at an all-time high, and stocks of unoccupied landmark buildings waiting to be snapped up, it's inevitable

Soho House, Chicago.

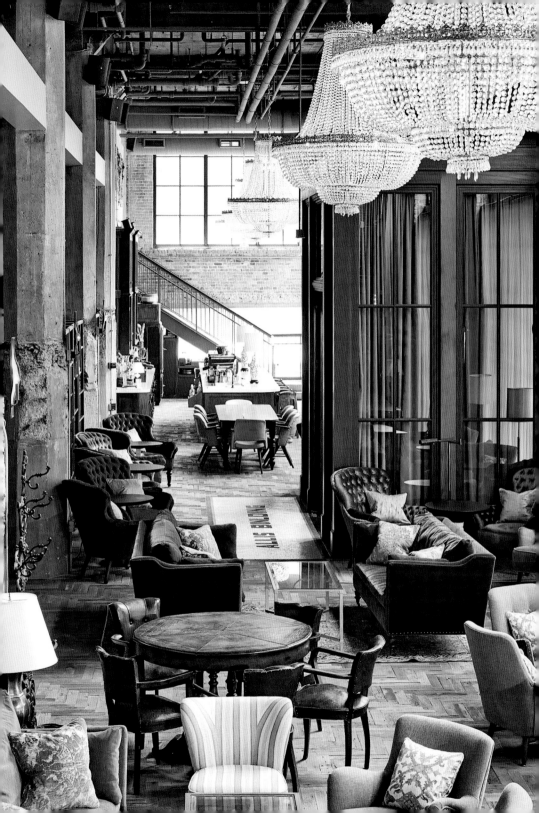

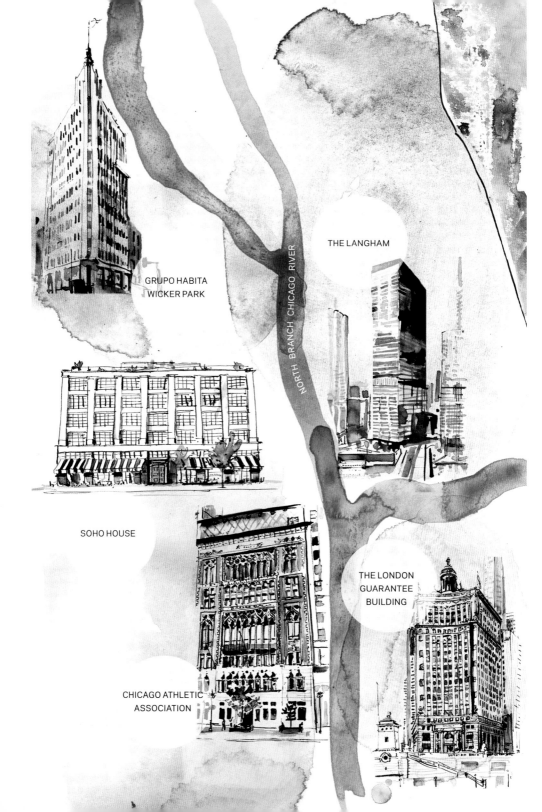

GRUPO HABITA
WICKER PARK

NORTH BRANCH CHICAGO RIVER

THE LANGHAM

SOHO HOUSE

THE LONDON
GUARANTEE
BUILDING

CHICAGO ATHLETIC
ASSOCIATION

that developers should come up with a contemporary solution to the city's once staid hospitality industry. The imposing Beaux Arts tower of the **London Guarantee Building,** known as one of the four 1920s anchors of the Michigan Avenue Bridge, is currently being reconditioned into a 452-room hotel by developers Oxford Capital Group, who have recruited the skills of local firm Goettsch Partners to restore the exterior and arrange the inside to include – along with a restaurant, spa, and ballroom, and a host of public areas – two floors of retail space. A new twenty-one-storey modernist addition, which will serve as the hotel's entry on Wacker Drive, has also been promised.

All of these new developments reflect the global changes of how we now eat, drink, play, and sleep. The competition for an outstanding place to bed down is intense, and what was once exceptional has become the norm. San Francisco-based Commune Hotels + Resorts (the hotel management company behind the hip Thompson group) have upped the ante with a new, 240-room project in the monumental **Chicago Athletic Association.** Designed by architect Henry Ives Cobb, the Venetian-Gothic structure was constructed in the 1890s as a meeting place for the city's elite to play sports and mingle. The building is currently undergoing a major exterior and interior refurbishment that has included bulldozing two-thirds of the rear – all of which will bring a new sense of meaning to the historic architecture. For this, plaudits go to New York–based design firm Roman and Williams, which will also convert the existing gym into a ballroom, while a new sports room and pool hall with a bar pay homage to the building's heritage.

Farther north, in Wicker Park, another historic tower is set to receive new tenants. Snagged by local firm Convexity Properties, the 1929 Art Deco tower, one of the first skyscrapers built outside downtown Chicago, will receive a complete restoration and become home to a new **Habita** hotel. Currently with fourteen properties in Mexico and one in New York City, the design-led group has gained a reputation for its edgy collaborations with star designers from Joseph Dirand to India Mahdavi. The Chicago version is to be dressed by Belgian architect Nicolas Schuybroek and will include the addition of a rooftop tower and the rehabilitation of the adjacent Hollander Fireproof Warehouses building, which will serve as the hotel's event space.

Currently one of the cleanest and most attractive places in the U.S., Chicago is slowly building momentum to reclaim its rightful status as one of America's star cities.

MY FAVOURITE HOTEL

One of the undisputed perks of working in fashion is the travel. Whether for shoots, shows, or just for a little R & R, industry insiders get to see the interior of endless hotel rooms. Who better, then, to share their personal design gems than some of fashion's highest-flying creatives?

PETER PILOTTO AND CHRISTOPHER DE VOS

Fashion Designers

THE COVENT GARDEN HOTEL, *London, U.K.*

'We love the Covent Garden Hotel on Monmouth Street. It has such a classic English feel, yet remains fresh and modern. We love that all the rooms are individually designed – it gives the place a very homey vibe. In fact, it's like a home away from home. We're always playing on the modernisation of techniques or styles in our designs, so we appreciate those juxtapositions within the hotel. The wood-panelled drawing room with its French stone fireplace is a great place to meet someone for breakfast or a cup of tea – although our most memorable times spent here are the ones of which we have little or no memory at all!'

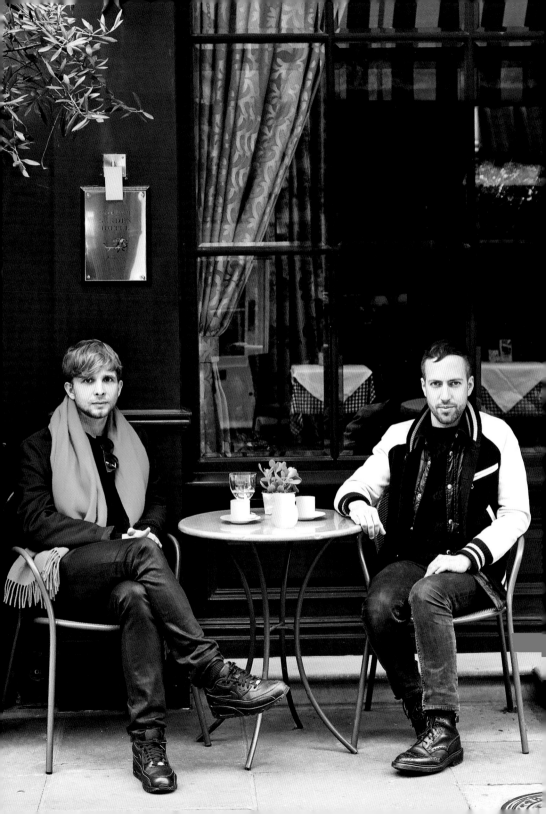

ALEX BOX
MAKEUP ARTIST

PALAZZO MARGHERITA, *Bernalda, Italy*

'This beautiful secret in the middle of "real working" Italy, owned by Francis Ford Coppola, feels like a still from one of Coppola's films – a poetic moment – its fading frescoes and delicately chosen colour palette bleached by hazy Italian sun. I like to stay in Suite Nine: It's like going back in time, a beautiful mixture of hand-painted folk tiles and regency opulence; part finca, part Moroccan souk, part 1930s Hollywood recluse's boudoir. It's a place that makes you float, the feeling echoed by the ceiling fresco, painted like infinite swirling skies...close to heaven.'

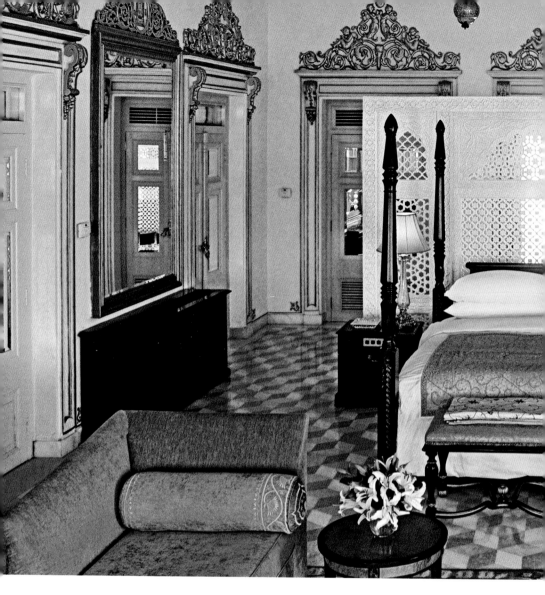

NORA AL-SUWAITI

FASHION DIRECTOR

TAJ LAKE PALACE, *Udaipur, India*

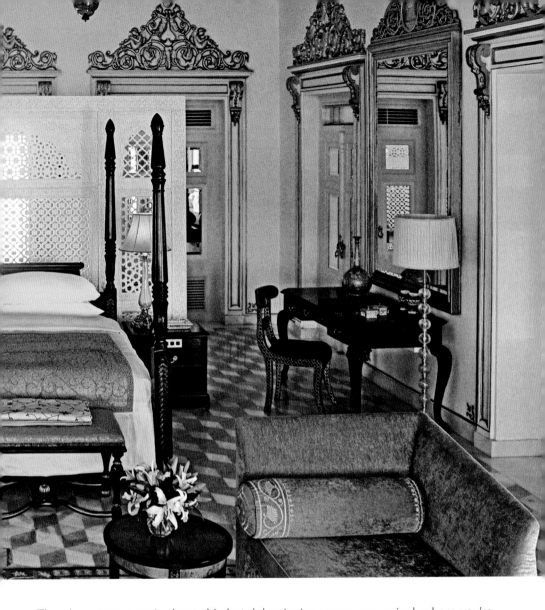

'There's a very sexy air about this hotel, beginning upon your arrival, where you're showered with rose petals before proceeding through this magnificent palace of carved marble and floating gardens. The rooms surround the palace garden, which gives the atmosphere an original beauty and indigenous charm. The experience couldn't be more wonderful in this setting of old-world beauty. One of my favourite corners is the pool, which hides behind a reflective silver-engraved wall and is filled with cascading bougainvillea – there you can experience true serenity.'

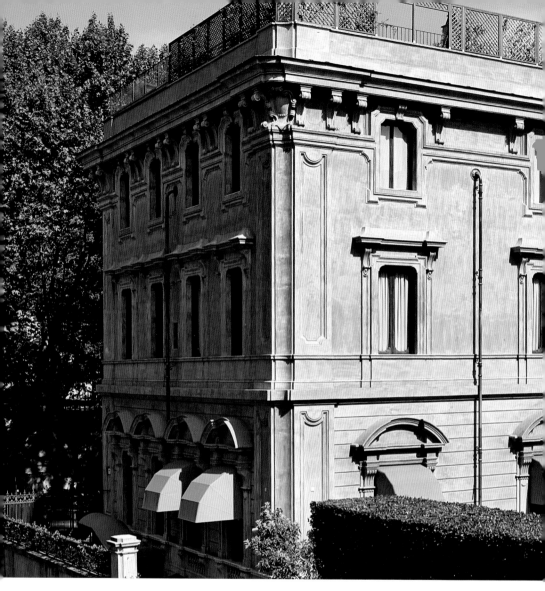

SCOTT SCHUMAN
PHOTOGRAPHER

VILLA SPALLETTI TRIVELLI, *Rome, Italy*

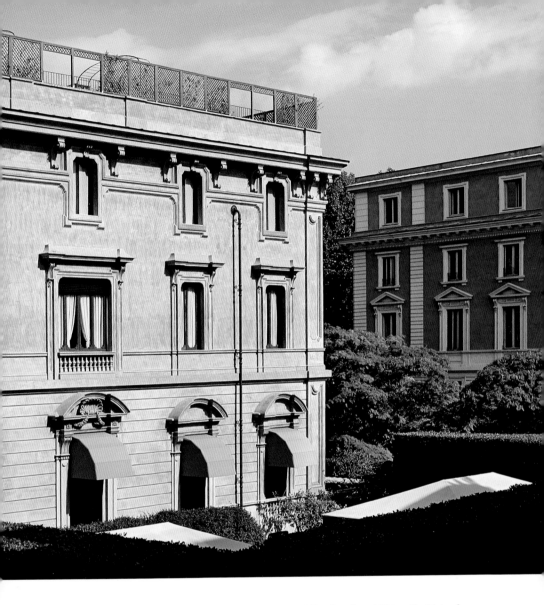

'My favourite place to stay when in Rome is Villa Spalletti Trivelli. This former private home has been updated just enough so that it's comfortably modern, but I still feel like the eldest son staying at his parents' house for a break. Each room has a classic Italian flair, with just the right unexpected modern element to keep it from feeling like a museum. I spent one blissful morning here carefully discovering every chic detail and imagining what it was like to live in the heyday of Rome.'

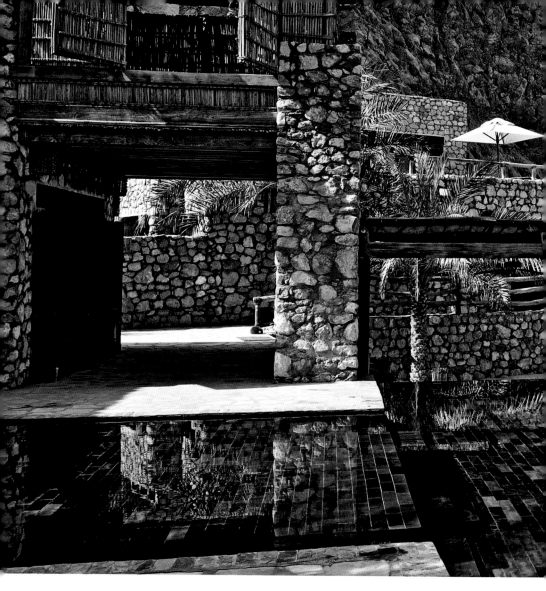

NICHOLAS KIRKWOOD
SHOE DESIGNER

SIX SENSES ZIGHY BAY, *Oman*

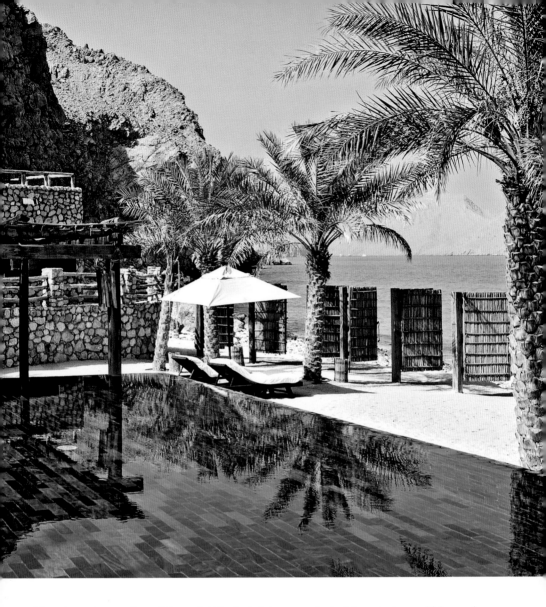

'The location and position of this hotel in a secluded bay is incredible and so isolated. You have to go over a mountain to get there. The villas open up right onto the beach, and they blend into the surroundings with the mountains behind. The hotel's design and décor is inspired by traditional Omani architecture, with real attention to detail. Its guests are also so interesting and international.'

GO GREEN

WHITEPOD
Les Cerniers, Switzerland

Camping on a snowy mountainside may seem way off your vacation to-do list, but thanks to a sustainably focused initiative in the Swiss Alps, you may want to amend that list. Whitepod blends high design (think innovative Buckminster Fuller–inspired geodesic domes) with luxury interiors and pioneering environmental thinking, designed to leave an almost invisible footprint on the local environment. Fifteen domes are dotted around a traditional wooden lodge, each with solar power and wood-burning stoves – so guests don't feel those Alpine chills 1,400 metres up – plus king-sized beds and proper bathrooms. The temporary nature of the structures means very little impact on the local environment, and the project supplements its energy consumption with power from renewable sources. Choose between dog sledding and skiing in winter or climbing and mountain biking in summer for a guilt-free outdoor adventure.

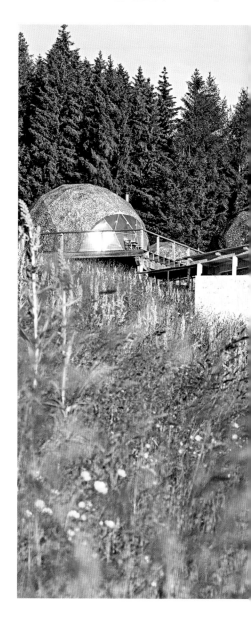

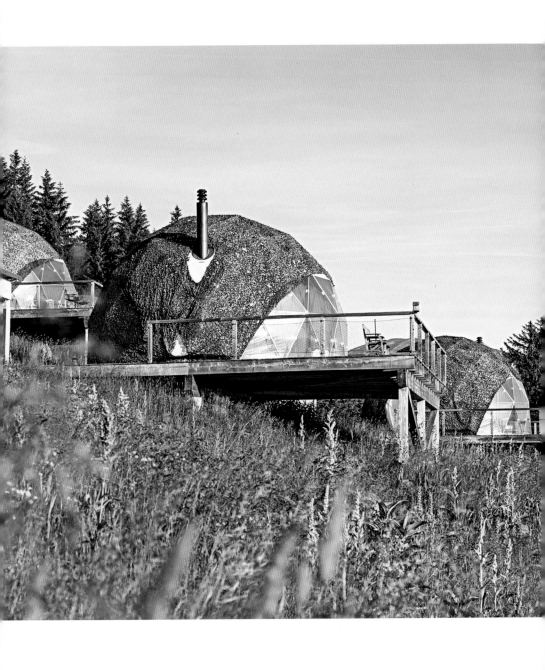

DESIGN LOVERS

Husband and wife James Russell and Hannah Plumb create modern assemblages using forgotten objects. Founders of the design studio **JamesPlumb,** their distinctive creations encompass layers of intriguing narratives, amassed over time. When designing the interior of the East London–based boutique **Hostem,** the duo salvaged Georgian corner cupboards and a medieval stairwell. There is even a Chesterfield sofa with a table erupting from its centre. Farfetch asked the duo how they balance their work/romance time frames and who takes the reins at home and in the studio:

ON HOW THEY MET

Hannah: We met at Wimbledon School of Art. Our tutor used to smoke Gitanes cigarettes and tell stories about swapping paintings with Francis Bacon when he was at art school himself.

James: Hannah's background was focused on animism and empathy with objects. Mine was focused on working with beauty in the everyday. When we began working together, we were able to combine the two and create something even more potent.

ON THEIR PROFESSIONAL LIFE

Hannah: It's exciting! Our work and home life is perfectly intertwined. There is no start-and-stop watch for which hat I should be wearing – home or work.

James: We began working together almost immediately. There was work to be done, and our styles were naturally complementary, as well as our natural excitement and passion for what we do.

ON THEIR AESTHETIC

James: We seek out inspiring and wonderful things on behalf of our clients, and that can happen anywhere. A walk to our local shop can inspire us, or a memory we have of watching a balloon spinning serenely on a ceiling fan above a vegetable stall in Shanghai.

Hannah: Perhaps our biggest influence is empathy and emotional resonance. We respond emotionally to things and places, and the world is so fast that it is important to create objects and environments that people can really connect with.

ON WHO WEARS THE TROUSERS

Hannah: There's no overruling each other – and it's not like there aren't disagreements – but in the end it's a common voice. That's why our studio is a combination of both our names. It's neither of us, and both of us. JamesPlumb wears the trousers.

James: It's so blurred that it's just not something that enters our head. We're very busy, so there's no time to worry about that – it's less about who's wearing the trousers and more about moving ideas back and forth between us to refine them and get to the point of pure excitement.

ON WORKING TOGETHER AS HUSBAND AND WIFE

Hannah: We don't have to catch up with each other at the end of a day. And we continue to see some amazing places together when our projects take us overseas.

James: We live and breathe our projects without sacrificing our relationship, but actually strengthening it. There's no taboo about bringing work home, because it's the same for both of us. So we can be uncompromising and demanding of ourselves and talk about our ideas all the time, without boring the other half!

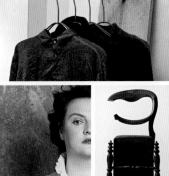
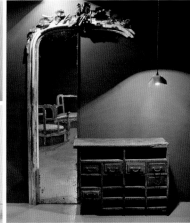

FARFETCH CURATES DESIGN DIRECTORY

AUSTRIA

BUS:STOP
Krumbach
Lower Austria, 2851

■■▪ **LISKA**
Graben 12
1010 Vienna
Tel: +43 1 5124120
liskafashion.com

BELGIUM

■■▪ **IRINA KHÄ**
Rue du Pot d'Or 12
4000 Liege
Tel: +32 4 221 21 35
irina-kha.com

■ **RIO STORE**
Lange Kruisstraat 29
9000 Ghent
Tel: +32 9 233 50 25
riostore.be

■■ **VERSO**
Lange Gasthuisstraat 11
2000 Antwerp
Tel: +32 3 226 92 92
verso.com

BRAZIL

**ZEN SANCTUARY
DESIGN BEACH HOME**
Ilhabela, São Paulo

CANADA

■ **CAHIER D'EXERCICES**
369 rue St-Paul O
Montreal, Quebec H2Y 2A7
Tel: +1 514 439 5169
cahierdexercices.com

FOGO ISLAND INN
Joe Batt's Arm
Newfoundland
Tel: +1 709 658 3444
fogoislandinn.ca

■■ **TNT**
4100 rue St-Catherine O
Montreal, Quebec H3Z 3C9
Tel: +1 514 935 1588
tntfashion.ca

CYPRUS

■■ **SPLASH BY THE BEACH**
Georgiou A, 131
Lordos Beach Garden
Limassol 4048
Tel: +357 25 355571
splash.com.cy

CZECH REPUBLIC

BROKIS
brokis.cz

THE EMBLEM HOTEL
Platnéřská 111/19
111 00 Prague
Tel: +420 226 202 500
emblemprague.com

GALLERY KŘEHKÝ
Haštalská 6
110 00 Prague
Tel: +420 267 990 545
krehky.cz

HOTEL JOSEF
Rybná 693/20
110 00 Prague
Tel: +420 221 700 111
designhotels.com

LASVIT
Komunardů 32
170 00 Prague
Tel: +420 222 362 990
lasvit.com

NANOVO
Kolbenova 616
190 00 Prague
Tel: +420 603 145 362
nanovo.cz

FRANCE

■■ **CAPSULE BY ESO**
21 rue Gentil
69002 Lyon
Tel: +33 4 78 91 17 85
capsulebyeso.com

■■ **L'ECLAIREUR**
40 rue de Sévigné
75003 Paris
Tel: +33 1 48 87 10 22
leclaireur.com

■ **MODE DE VUE**
53 rue de Turenne
75003 Paris
Tel: +33 1 42 77 02 88
modedevue.com

GERMANY

■ **ANDREAS MURKUDIS**
Potsdamer Strasse 81E
10785 Berlin
Tel: +49 30 680 798 306
andreasmurkudis.com

■ **AUGUST PFUELLER**
Goethestrasse 15
60313 Frankfurt am Main
Tel: +49 69 133 780 60
august-pfueller.de

■ **BUNGALOW GALLERY**
Stiftstrasse 1A
70173 Stuttgart
Tel: +49 711 220 2000
bungalow-gallery.com

■■ **THE CORNER BERLIN**
Französische Strasse 40
10117 Berlin
Tel: +49 30 20 670 940
thecornerberlin.de

■ **VOO STORE**
Oranienstrasse 24
10999 Berlin
Tel: +49 30 695 797 2710
vooberlin.com

GREECE

■■ **LUISA WORLD**
15 Skoufa Street
10673 Kolonaki, Athens
Tel: +30 21 0363 5600
luisaworld.com

HUNGARY

■■ **IL BACIO DI STILE**
19 Andrássy Avenue
1061 Budapest
Tel: +36 1 211 1000
ilbaciodistile.com

INDIA

TAJ LAKE PALACE
Pichola
Udaipur, Rajasthan
313001
Tel: +91 294 242 8800
tajhotels.com

INDONESIA

ABODAY
aboday.com

ALVINT
alvin-t.com

KARSA
karsa.co

SUB
subvisionary.com

IRELAND

J. HILL'S STANDARD
jhillsstandard.com

MAKERS & BROTHERS
Abbey Court
Blackrock, Co. Dublin
Tel: +353 1 663 8080
makersandbrothers.com

ITALY

■■ **BABYLON BUS WOMEN**
Viale Piave, 25
59100 Prato
Tel: +39 0574 433114
babylonbusonline.com

BOSCO VERTICALE
Via Gaetano de Castilla &
Via Federico Confalonieri
20124 Milan
Tel: +39 02 45475195-96
porta-nuova.com

■■ **CUCCUINI**
Via Ricasoli, 35
57125 Livorno
Tel: + 39 0586 899512
cuccuini.it

■■ **CUMINI**
Via San Daniele, 1
33013 Gemona del Friuli
Tel: +39 0432 971181
cumini.it

■■ **DOLCI TRAME**
Via del Moro, 4
53100 Siena
Tel: +39 0577 46168
dolcitrameshop.com

■■ **ERALDO**
Via Roma, 92
30022 Ceggia (Venice)
Tel: +39 0421 329567
eraldo.it

■■ **NUGNES 1920**
Corso Vittorio Emanuele,
195
76125 Trani (BT)
Tel: +39 0883 509017
nugnes1920.it

■■ **O'**
Via Nazario Sauro, 10
43121 Parma
Tel: +39 0521 232886
ostoreparma.wix.com/
officinastore

FARFETCH CURATES DESIGN DIRECTORY

PALAZZO MARGHERITA
Corso Umberto I, 64
75012 Bernalda, Matera
Tel: +39 0835 549060
coppolaresorts.com/
palazzomargherita

■■ **STEFANIA MODE**
Via Torre Arsa, 27
91100 Trapani
Tel: +39 0923 593161
stefaniamode.it

■■ **TIZIANA FAUSTI**
Piazza Dante
24121 Bergamo
Tel: +39 035 224142
tizianafausti.it

**VILLA SPALLETTI
TRIVELLI**
Via Piacenza, 4
00184 Rome
Tel: +39 06 4890 7934
villaspalletti.it/it/

KUWAIT

■■ **AL OSTOURA**
Salem Al Mubarak Street
Salmiya, Kuwait
Tel: +965 2208 9229
alostoura.com

NETHERLANDS

PIET HEIN EEK
Halvemaanstraat 30
5651 BP Eindhoven
Tel: +31 40 2856610
pietheineek.nl

■■ **STYLESUITE**
Rechtstraat 63a
6221EH Maastricht
Tel: +31 438524052
stylesuite.nl

NORWAY

ROADSIDE LAVATORY
Akkarvikodden, Lofoten

OMAN

SIX SENSES ZIGHY BAY
Musandam Peninsula
Dibba Bayeh
Tel: +968 2673 5555
sixsenses.com/resorts/
zighy-bay/destination

POLAND

■■ **VITKAC**
Bracka 9
00-501 Warsaw
Tel: +48 22 310 73 13
vitkac.com

SPAIN

■■ **GALLERY MADRID**
Calle de Jorge Juan, 38
28001 Madrid
Tel: +34 915 76 79 31
gallerymadrid.com

■■ **JOFRÉ**
Carrer de Bori i Fontestà, 6
08021 Barcelona
Tel: +34 932 09 52 81
jofre.eu

■■ **OTTODISANPIETRO**
Rúa Juan Flórez, 41
15004 A Coruña
Tel: +34 981 12 11 23
ottodisanpietro.com

SWITZERLAND

HOTEL WHITEPOD
Les Giettes, Les Cerniers
1871 Monthey
Tel: +41 24 471 38 38
whitepod.com

TAIWAN

ESAILA
esaila.com

FABRAFT
fabraft.com

KENYON YEH
kenyonyeh.com

TAIPEI 101
No. 45 Shifu Road
Xinyi District
Taipei City 110
taipei-101.com

U.K.

■■ **BROWNS**
24–27 South Molton Street
London W1K 5RD
Tel: +44 20 7514 0016
brownsfashion.com

COVENT GARDEN HOTEL
10 Monmouth Street
London WC2H 9HB
Tel: +44 20 7806 1000
firmdalehotels.com

■■ **HOSTEM**
41–43 Redchurch Street
London E2 7DJ
Tel: +44 20 7739 9733
hostem.co.uk

JAMESPLUMB
jamesplumb.co.uk

■■ **THE SHOP AT BLUEBIRD**
350 King's Road,
London SW3 5UU
Tel: +44 20 7351 3873
theshopatbluebird.com

URSA
+44 20 7739 0222
ursalondon.com

**V&A MUSEUM OF
DESIGN, DUNDEE**
Dundee, Angus DD1 4QB
vandadundee.org

U.S.

■ **ALCHEMIST**
Lincoln Road Mall
1109 Lincoln Road
Miami Beach, Florida 33139
Tel: +1 305 531 4653
shopalchemist.com

■■ **A'MAREE'S**
2241 West Coast Highway
Newport Beach, California
92663
Tel: + 1 949 642 4423
amarees.com

■■ **ANASTASIA**
460 Ocean Ave
Laguna Beach, California
92651
Tel: +1 949 497 8903
anastasiaboutique.com

■■ **ATELIER**
210 11th Avenue, Ste 1003
New York, New York 10001
Tel: +1 212 941 8435
ateliernewyork.com

**CALIFORNIA ACADEMY
OF SCIENCES**
55 Music Concourse Drive
San Francisco, California
94118
Tel: +1 415 379 8000
calacademy.org

**CHICAGO ATHLETIC
ASSOCIATION**
12 S Michigan Avenue
Chicago, Illinois 60603
Tel: +1 312 940 3552
chicagoathletichotel.com

ECCOLA
7408 Beverly Blvd
Los Angeles, CA 90036
Tel: +1 323 932 9922
eccolaimports.com

■■ **FORTY FIVE TEN**
4510 McKinney Ave
Dallas, Texas 75205
Tel: +1 214 559 4510
fortyfiveten.com

**GRUPO HABITA
WICKER PARK**
Northwest Towers
1170 W Erie Street
Chicago, Illinois 60641
Tel: +1 312 633 9057

■■ **H. LORENZO**
Sunset Plaza
8660 West Sunset Blvd
West Hollywood, California
90069
Tel: +1 310 659 1432
hlorenzo.com

■■ **KELLY WEARSTLER**
8440 Melrose Avenue,
West Hollywood, California
90069
Tel: +1 323 895 7880
kellywearstler.com

THE LANGHAM
330 N Wabash Avenue
Chicago, Illinois 60611
Tel: +1 312 923 9988
langhamhotels.com

■ **LINDA DRESNER**
299 W Maple Road
Birmingham, Michigan
48009
Tel: +1 248 642 4999
lindadresner.com

**LONDON GUARANTEE
BUILDING**
360 N Michigan Avenue
Chicago, Illinois 60601

SOHO HOUSE CHICAGO
113 N Green Street
Chicago, Illinois 60607
Tel: +1 312 521 8000
sohohousechicago.com

■ Indicates Farfetch
 Boutiques
■ Indicates Farfetch
 Boutiques That
 Carry Homeware

FARFETCH
CURATES DESIGN

EDITORIAL
Editorial Director Stephanie Horton
Editor in Chief Paul Brine
Features Editor Laura Hawkins
Fashion Features Editor Alannah Sparks
Sub Editor Jason Dike
Editorial Consultant John Matthew Gilligan

ART
Creative Director Peter Stitson
Art Editor Craig McCarthy
Picture Editor Robin Key

CURATORS
Lauren Ho, Dan Howarth, Tom Morris, Omar Sosa

PICTURES
Objects of Affection Roger Casas
Hot Seat Patricia Neligan, Christoffer Rudquist, Joe Schmelzer, Yoann Stoeckel
Go Green Tim Griffith, Micha Riechsteiner, Inge Vandamme
Design Off the Beaten Path Adolf Bereuter, Alex Fradkin, Nelson Kon
Spotlight on: Taipei Kenyon Yeh Studio, ShaoLan Hsueh, Yenwen Tseng Studio
The New Design Capitals Sarah Maycock
Open House Michael Danner, Jason Keen, Yoann Stoeckel
Hotel Hotspot Sarah Maycock
My Favourite Hotel Angela Moore (Peter Pilotto portrait)
Design Lovers Christoffer Rudquist
Jacket and page 57 Ettore Sottsass, *Geology 8*, 2000, ceramic, edition 4/12
© 2015 Artists Rights Society (ARS), New York/ADAGP, Paris

WORDS
Objects of Affection Laura Hawkins
Hot Seat Laura Hawkins
Go Green Laura Hawkins, Paul Brine
Design Off the Beaten Path Paul Brine
Spotlight on: Taipei Dan Howarth
Shop Style Laura Hawkins
The New Design Capitals Tom Morris
Open House Laura Hawkins
Hotel Hotspot Lauren Ho
My Favourite Hotel Alannah Sparks
Design Lovers Laura Hawkins

© 2015 Assouline Publishing
601 West 26th Street, 18th floor, New York, NY 10001, USA
Tel.: 212-989-6769 Fax: 212-647-0005
assouline.com
Printed in China.
ISBN: 9781614284475

FARFETCH
Harella House
90-98 Goswell Rd
London
EC1V 7DF
curates@farfetch.com